# BEAD MAKING LAB

# BEAD MAKING LAB

52 EXPLORATIONS FOR CRAFTING BEADS
FROM POLYMER CLAY, PLASTIC, PAPER,
STONE, WOOD, FIBER, AND WIRE

HEATHER POWERS

QUARRY

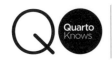

Quarto is the authority on a wide range of topics.

Quarto educates, entertains and enriches the lives of our readers—enthusiasts and lovers of hands-on living.

www.QuartoKnows.com

First published in the United States of America in 2016 by
Quarry Books, an imprint of
Quarto Publishing Group USA Inc.
100 Cummings Center
Suite 406-L
Beverly, Massachusetts 01915-6101
Telephone: (978) 282-9590
Fax: (978) 283-2742
QuartoKnows.com
Visit our blogs at QuartoKnows.com

10 9 8 7 6 5 4 3 2 1

ISBN: 978-1-63159-114-3

Digital edition published in 2016
eISBN: 978-1-63159-182-2

Library of Congress Cataloging-in-Publication Data is available.

Design: Leigh Ring // www.ringartdesign.com
Cover Image: Glenn Scott
Photography: Heather Powers; Glenn Scott Photography // www.glennscottphotography.com
on pages 8-9, 14, 16, 18, 20,22, 24,26, 28, 30, 32, 36, 38, 40, 42, 44, 46, 48, 50, 52, 54, 56, 58, 60, 62, 64, 66, 68, 70, 72, 74, 76, 78, 80, 82, 84, 88, 90, 92, 94, 96, 98, 100, 102, 106, 108, 110, 112, 114, 116, 118, 120, 122, 124, 126, 130, 132, 134, 136.

Printed in China

This book is dedicated to the incredible art bead makers and jewelry designers that grace my life. Thank you for the years of inspiration, friendship, and community.

A special thanks to the *Art Bead Scene* contributors both past and present, who help spread the word about handcrafted and artisan beads and who share my addiction for all things bead related.

Much love to my very supportive family—my hard working partner, Jess, and our daughters Hannah and Evangeline. And a sincere thanks to my biggest cheerleaders: Mom and Rosanne—what would I do without your encouragement and love!

# CONTENTS

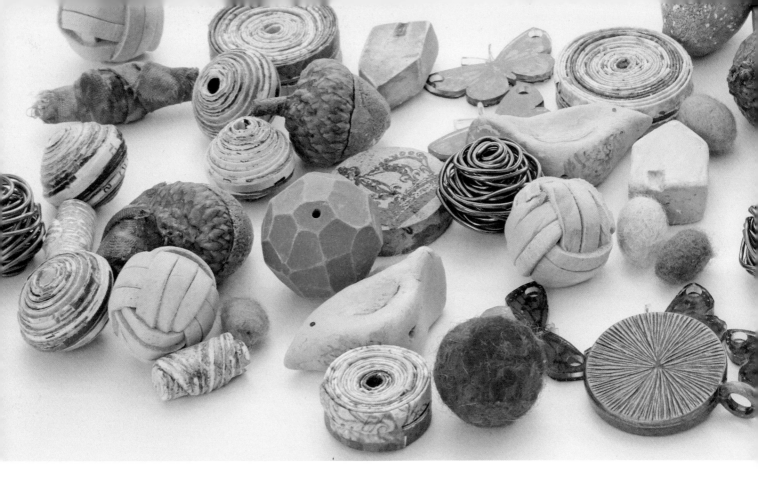

# INTRODUCTION

**I DISCOVERED BEADS OVER TWENTY YEARS AGO WHEN I STUMBLED UPON A LITTLE SHOP WITH A DISPLAY OF BEADS AMID CRYSTALS AND OTHER COLLECTIBLES. I CAN'T EXPLAIN WHAT HAPPENED: I THINK IT WAS LOVE AT FIRST SIGHT. I WAS SUDDENLY OBSESSED WITH THESE TINY THINGS!**

After realizing there was an entire world of beads, I spent hours in my art school library poring over books filled with ancient examples of handmade beads. I read magazines like *Ornament* that showed the cutting edge of modern mediums, and I studied the few books available in our library on jewelry making. I fell hard for this new love and soaked up everything I could about the world of beads.

It wasn't long before I was smitten with the idea of making my own beads. I discovered the low-tech and color-drenched world of polymer clay and have been making my own beads ever since. I now make my living selling my handcrafted art beads.

I love that, with a few basic materials, you can create focal points for your jewelry that are limited only by your own imagination. This book covers beads created from materials

that can be found in craft shops and hardware stores. With simple tools and craft materials, I explore a wide variety of ways to create beads. These Labs are just the starting point for your own love affair with handcrafted beads. I hope they spark your imagination as you dig deeper and explore the materials covered.

## HOW TO USE THIS BOOK

Each project in the book is a stand-alone project. You can work though the book like a course on bead making or jump back and forth trying new mediums that catch your eye. Check the basics at the start of each unit for valuable pointers before you start on a new medium. Carefully read through the directions before starting a project: Some of the steps are not shown in photos. Throughout the book, you'll find examples of beads from professional artists who

are working in similar media. I showcase four artists who work in a range of materials to create unique mixed-media jewelry. At the start of each unit, you'll find a gallery of jewelry that I've created from the beads featured in the fifty-two labs. Here, you'll find lots of ways to incorporate your new beads into jewelry.

Whether you are just starting out with your bead crush or fanning the flames of a long love affair, I hope you find *Bead-Making Lab* inspiring and educational as you explore a year's worth of bead-making projects.

*—Heather Powers*

# BEAD-MAKING TOOLS

*Pliers and wire cutters*

*Ball-peen hammer and bench block*

*General-use craft tools*

You could easily have many of these tools in your craft and jewelry-making supplies. Most can be found at any craft store, and a few will require a quick trip to the hardware store.

## JEWELRY TOOLS

### PLIERS AND WIRE CUTTERS

• Round nose pliers—Use these to create loops with wire.

• Chain- and flat-nose pliers—Use these to bend wire, open jump rings, and hold onto small objects.

• Wire cutters—Look for flush cutters with a flat side to create clean cuts on wire. Heavy-duty cutters or memory-wire cutters are needed for steel wire.

• Ball-peen hammer—This hammer with one side flat and one side rounded is used to flatten and texture wire and metal.

• Bench block—This small steel block is used with the ball-peen hammer to flatten wire.

*Stamping and shaping tools*

*Paintbrushes*

*Foam sponge with felting and sewing needles*

## GENERAL CRAFT TOOLS

• Hole punch, scissors, and craft knife

• Rubber stamps and cookie cutters

• Paintbrushes with soft, synthetic fibers suitable for acrylics or watercolors

## FELTING AND SEWING

• Foam sponge—Use a synthetic kitchen sponge or a dense foam felting sponge.

• Felting needles—These long, sharp needles are barbed to grab and interlock fibers.

• Sewing and beading needles—Beading needles have a very thin head. Thicker sewing needles are used with embroidery floss. Large darning needles can be used to shape polymer clay.

*Pin-vise drill and mini hacksaw*

*Embossing heat tool and rotary tool*

*Leather spoon and shaper tool*

## SPECIALTY TOOLS

• Mini hacksaw—Use this for sawing wood and twigs.

• Pin-vise drill—This hand-operated mini drill is used for making holes in softer materials such as wood and polymer clay.

• Rotary tool, sanding bands, drill bit, and diamond drill bits—Use diamond drill bits for drilling harder materials such as glass and stone. Look for drill bits that are 1.5 or 2 mm thick. Use 240-grit sanding bands and a 2 mm drill bit for easier bead making. All the projects in this book use the rotary tool on the slowest setting.

• Embossing heat tool—Use this scrapbooking tool for setting paint and melting embossing powder.

• Styrofoam block—Use this to hold beads upright as they dry.

• Mold putty—Use this two-part mold material for making impressions from buttons and nature materials.

• Leather spoon and shaper tool—Use the shaper part of the tool that looks like a dull knife to shape lines into leather. The spoon is used to create impressions for dimensional designs on the leather.

## POLYMER-CLAY TOOLS AND MATERIALS

• Pasta machine or clay-conditioning machine—This will roll out clay in thin, even sheets.

• Cutting blade—Use a thin tissue blade 3 to 4 inches (10.2 cm) long for cutting polymer clay.

• Sculpting tool—A stylus with a rounded point is a great bead-sculpting tool. A thick darning needle will work, too.

*Pasta machine, sculpting tool, tissue blade, acrylic roller*

*Galvanized wire mandrels and bead rack*

• Acrylic roller—Use this to flatten and shape clay; it can be used instead of a pasta machine.

• Translucent liquid polymer clay—This can be brushed on and used as a glue for polymer clay.

• Microcrystalline wax—I always use Renaissance wax, and it's the only material used in this book that must be ordered online. There isn't a substitute that works the same. A small container will last a very long time. It's the perfect finish for polymer clay, offering protection for surface treatments. Use very thin coats to avoid clouding. The wax will melt with the temperature of your fingers. Apply it with your fingers and buff with a soft cloth.

• Bead rack—This is a specialty rack found where polymer clay is sold. The slats hold beads on wires so they can bake without touching the pan. If you don't have a bead rack, you can create holders with scrap clay to keep the beads and wire from touching the baking pan. An accordion-folded piece of paper will also work. Fold the paper, place it on the pan, and rest the beads on bead mandrels (see next entry) to bake while they are being held in the folds of the paper.

• Bead Mandrels—For this you'll need 18-gauge galvanized-steel wire. Cut the wire into 4-inch (10.2 cm) and 8-inch (20.3 cm) lengths. Straighten the wire with chain-nose pliers to create your own bead mandrels, which are used to poke holes in beads, support beads while they bake, and hold beads as they dry. Galvanized-steel wire is a very stiff wire available in hardware stores. Use heavy-duty wire cutters to trim it.

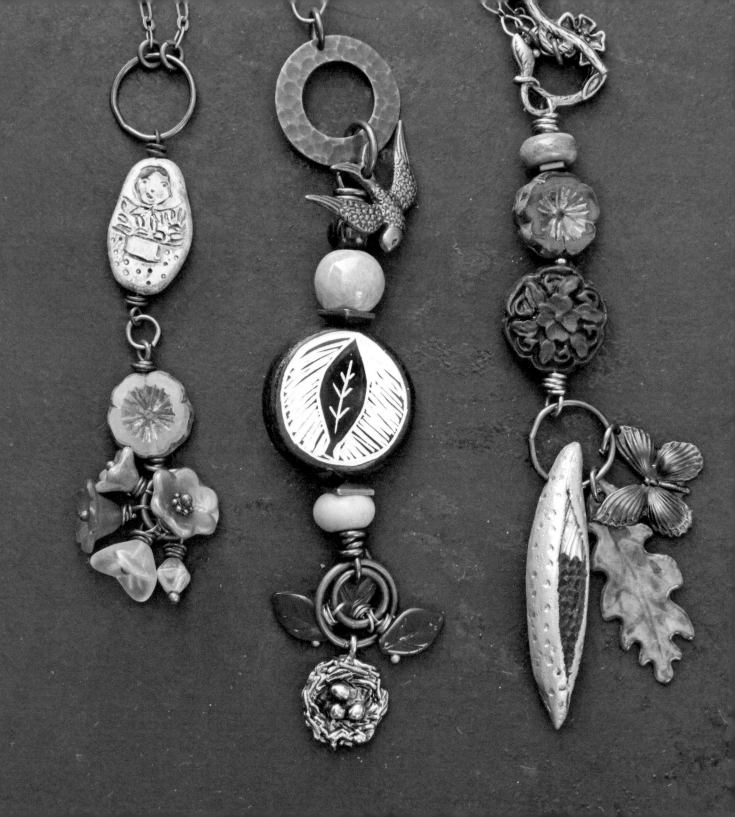

# UNIT
# 01

# CLAY

## CLAY BASICS

**Polymer clay** is by far my favorite medium. It's lightweight, mimics many materials, and comes in wonderful colors. Always work on a glass, tile, or plexiglass surface; polymer clay will ruin a wood tabletop.

Before use, condition the clay by pinching and folding it over several times until it's malleable.

When baking polymer beads, follow the manufacturer's directions. Use an oven thermometer and keep track of your baking time; polymer releases noxious fumes when it's burned. If you bake polymer beads in your kitchen oven, cover them lightly with a foil tent. Place a piece of paper on the bottom of your pan to prevent shiny spots from appearing on the beads.

Never use kitchen utensils for working with polymer clay: once you do, they can no longer be used for food prep. Store the clay in a cool, dry place wrapped in baggies or waxed paper.

**Air-dry clay** is a little more difficult to work with than polymer. The drying time requires patience, but the ceramic-like finish and durability of this clay makes it ideal for small beads.

Before using the clay, be sure to condition it by pinching and folding it between your fingers. This releases moisture in the clay, allowing for a smoother finish. While making beads, pinch off only a small amount at one time, keeping the rest sealed in a baggie.

# LAB 01 SGRAFFITO BEADS

## TOOLS AND MATERIALS

→ White polymer clay
(I recommend only Soufflé or Premo—both from Sculpey.)

→ Acrylic clay roller

→ 4″ (10.2 cm) piece of 18-gauge wire

→ Baking sheet

→ 400-grit wet/dry automotive sandpaper

→ Permanent patina paint
(See Note below.)

→ Waxed paper

→ Paintbrush

→ Embossing heat tool

→ Photocopier

→ #2 pencil

→ Lino cutter with small V cutter

→ Microcrystalline wax
(I used Renaissance wax.)

*Note: Permanent patina paint is available in small bottles in craft stores; I used Vintaj Patina paints.*

**THESE POLYMER CLAY BEADS BORROW A POTTERY-DECORATION TECHNIQUE—SGRAFFITO—IN WHICH A PAINTED SURFACE IS CARVED AWAY TO REVEAL THE DESIGN.** This technique requires the use of a photocopier and an embossing heat tool, which can be found wherever scrapbooking supplies are sold.

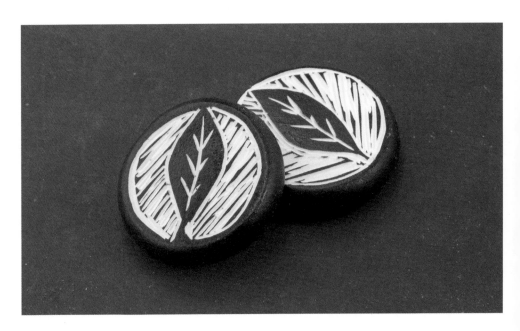

1. Condition the clay. Roll a 1″ (2.5 cm) ball of clay between your palms. Place the ball on your work surface and flatten it lightly with the acrylic roller. Turn the bead over and roll it again to an even thickness at least ¼″ (6 mm) -thick. (Fig. 1)

2. Use the wire to poke a hole through the beads lengthwise. Place the beads on the baking sheet and bake them according to the manufacturer's directions. Remove the beads from the oven and allow them to cool. Sand the surface of the beads until smooth.

3. Place a drop or two of paint on a small piece of wax paper. Brush a thin, even coat of paint on one side of the beads. Allow them to dry, and then turn them over and paint the other side. When dry, paint the sides of the beads. Repeat, applying a second coat of patina paint. Apply a thin layer of wax with your finger on both sides of the bead.

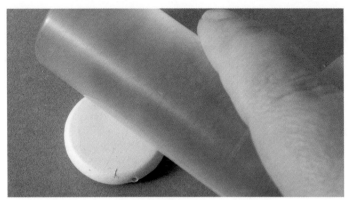

Fig. 1

Fig. 2

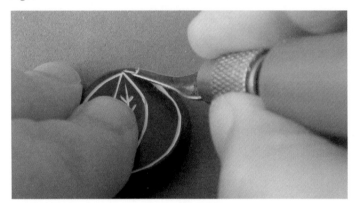

Fig. 3

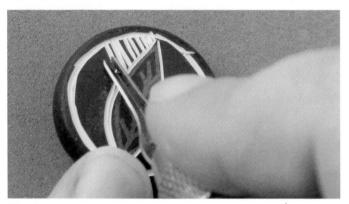

Fig. 4

4. With the embossing tool, heat each bead, one side at a time, for 10 to 15 seconds. Keep the heating tool 2″ to 3″ (5 to 6 cm) away from the beads. Do not allow the beads to overheat. Let the beads cool down before flipping them over to heat the other side.

5. Make a photocopy of the leaf on page 16. Cut out the image, turn it face down, and rub the back of the image with the pencil to give it an even coat of graphite. (Fig. 2)

6. Place the image, graphite side down, on top of the bead. Hold the paper in place securely. Firmly trace over the design with the pencil to transfer it to the bead. Set the paper aside.

7. Using the lino cutter, carve small, shallow cuts around the outline of the design, starting from the center and working outward. Carve around the top of the bead, leaving a small border. (Fig. 3)

8. Returning to the center, cut out the lines to add texture. Carve away the background. Add design interest by turning the bead in several directions and following the outlines of the designs. Repeat on the other side of the bead if desired. (Fig. 4)

## SAFETY TIP

When carving beads, work slowly. Always hold the bead at the base and carve away from your fingers. *Never* carve toward your fingers.

# OMBRÉ BEADS

## TOOLS AND MATERIALS

→ Polymer clay in 2 contrasting colors (I used white Premo and Soufflé in Jade.)

→ Acrylic roller

→ Pasta machine

→ Tissue blade

→ 4″ (10.2 cm) piece of 18-gauge wire

→ Baking sheet

→ 400- and 800-grit automotive wet/dry sandpaper (optional)

→ Shallow dish (optional)

→ Microcrystalline wax (I used Renaissance wax; this is optional.)

→ Soft cotton cloth or towel

## TIP

For best results in mixing and blending colors, I recommend using a pasta machine.

**A GREAT TECHNIQUE FOR YOUR POLYMER CLAY BEAD-MAKING BAG OF TRICKS IS COLOR GRADATION CALLED THE SKINNER BLEND, FIRST DEVELOPED BY JUDITH SKINNER.** This project makes the perfect ombré effect without a lot of fuss. Try this project in every color of the rainbow. When choosing two colors, make sure they have a high contrast (very light and very dark) to best show off this technique.

1. Condition half a block of each color of clay. Shape the clay into a thick rectangle with your hands and run the rectangle through the pasta machine set on the thickest setting. Repeat with the second color. Lay them side by side on your work surface. Trim the edges so that the rectangles are the same size.

2. Select one of the rectangles. Use the tissue blade to cut the rectangle diagonally in half to make two right triangles. Stack the triangles evenly. Repeat with the second rectangle. (Fig. 1)

3. Place the two stacked triangles next to one another to form a two-tone rectangle. Make sure they are touching along the seam.

*Fig. 1*

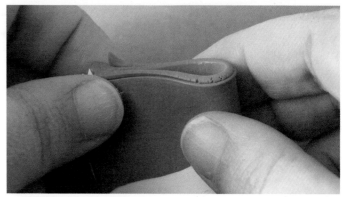

*Fig. 2*

*Fig. 3*

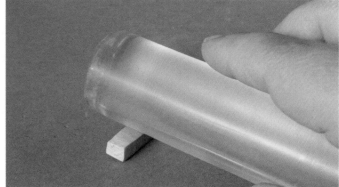

*Fig. 4*

4. Set the pasta machine to the thickest setting. Carefully pick up the rectangle and feed it into the pasta machine, short side first. Fold the clay in half so that the two short sides line up. (Fig. 2)

5. Repeat step 4 until the clay is well blended. It can take 10 to 15 passes to get an even blend. Expect the rolled clay to become wider each time it passes through the machine.

6. Lay the blended clay on your work surface. Trim the edges with the blade. Cut a ¼" (6 mm) -wide strip of the clay. Cut the strip into squares. Stack the squares to a height of about 1" (2.5 cm). (Fig. 3)

7. Lightly press the clay stack with your fingers to bond the squares together. Roll the clay lightly on all sides with the acrylic roller to shape the rectangular form of the beads. Use a gentle hand when rolling; not much pressure is needed. (Fig. 4)

8. Let the beads set for 15 to 20 minutes before continuing. Use the wire to poke a hole vertically through each. Twist the wire as you push it through the clay. Use a finger to push down on the bead as you twist the wire through it. You may want to poke the hole half way through the bead, remove it, then poke through on the other side until the holes meet in the middle.

9. Bake the beads on a baking sheet according to the manufacturer's directions. Allow them to cool.

10. Sand the beads if desired. To sand the beads, lay the 400-grit sandpaper on the bottom of a shallow dish and cover it with ¼" (6 mm) of water. Put the beads on top and rub them on the sandpaper. Repeat with the 800-grit sandpaper. Allow the beads to dry. Rub a light coat of wax on them. Buff with a soft cotton cloth or a towel.

# LAB 03   FACETED BEADS

## TOOLS AND MATERIALS

→ Polymer clay (I used Soufflé in Seaglass, Key Lime Pie, and Bluestone.)

→ 4" (10.2 cm) piece of 18-gauge wire

→ Baking sheet

→ Craft knife

→ 400-grit wet/dry automotive sandpaper

→ Microcrystalline wax (I used Renaissance wax.)

→ Soft cotton cloth or towel

**PLAY WITH THE SCALE OF THESE BEADS FOR A WIDE VARIETY OF JEWELRY-DESIGN IDEAS.**

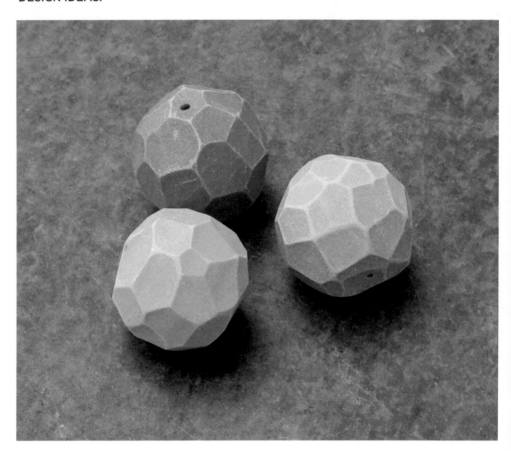

1. Condition the clay and roll a 1" (2.5 cm) ball in your palms. Repeat for as many beads as you wish to make. Use the wire to poke a hole through the beads. Place them on a baking sheet. Bake according to the manufacturer's directions. Remove them from the oven and allow them to cool completely. (Fig. 1)

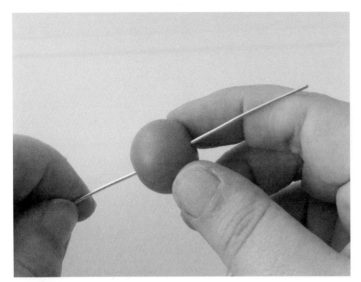

*Fig. 1*

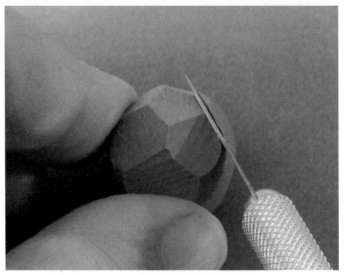

*Fig. 2*

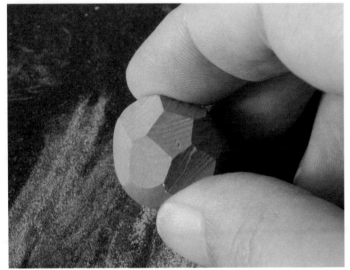

*Fig. 3*

2. Hold a bead securely on your work surface. Using the craft knife, cut a small piece off the bead, starting at the top and cutting downward. Turn the bead slightly and cut off another piece next to the first cut. Continue cutting, rotating the bead to create a faceted surface. (Fig. 2)

3. Sand the edges of the facets with fine sandpaper. Rub wax over the surface of the bead and buff with a soft cotton cloth or towel. (Fig. 3)

# MATRYOSHKA BEADS
## SCULPTED AND PAINTED

## TOOLS AND MATERIALS

→ White polymer clay
(I used Sculpey III.)

→ Acrylic roller

→ Darning needle or ink pen with
a smooth tip

→ 2" (5 cm) headpin

→ Baking sheet

→ Water

→ Paintbrush

→ Acrylic craft paint in a matte or
satin finish (See Note.)

→ Paper toweling

*Note: Pick 3 or 4 paint colors for
the fabric, a color for the faces,
pink for the cheeks, and raw
umber for the hair and antiquing.*

**THESE TINY NESTING-DOLL BEADS ARE CHARMING AND ORIGINAL.** Use a pen with a smooth tip to draw the designs on the fabric and the faces. Make the beads in different sizes and pair them for a playful bracelet or pendant.

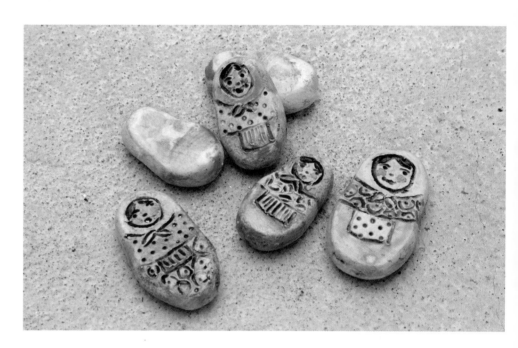

1. Roll a piece of clay in your palms to form a ball ¼" to ⅝" (6 mm to 1.6 cm) wide. The smaller the ball, the smaller the bead will be.

2. Roll the ball back and forth between your hands to shape it into an oval. Pinch the top of the oval to form the doll's head. Pinch the oval on the front and back to flatten it slightly. (Fig. 1)

3. Lay the bead on your work surface and flatten it evenly with the acrylic rod. Flip it over and roll it gently on the other side. The bead should be ³⁄₁₆" (4.8 mm) -thick.

4. With the tip of the ink pen, lightly draw a circle for the face. Continue to use a light hand while drawing the face and clothing patterns. Draw a curve for each eyebrow: center and poke a dot under each one for the eyes. Draw a tiny curve for the nose and small upturned curve for the mouth. (Fig. 2)

5. Draw the handkerchief under the face with a curved line that goes across the bead and two elongated ovals touching in the middle. Create the apron by drawing a curved line across the middle of the body and a small rectangle under the line.

6. Add patterns to the dolls' clothing. Make polka dots by poking the pen at evenly spaced intervals. Flowers are slightly irregular circles with a dot in the middle.

7. Use the headpin to poke a hole vertically through the beads. Place the beads on a baking sheet. Bake according to the manufacturer's directions. Remove from the oven and allow the beads cool completely.

8. Wet the paintbrush slightly before dipping it into the paint. Paint a thin coat of color on each section of the bead for the different fabric colors. Paint the skin tone for the face. Allow the beads to dry for at least an hour before proceeding. (Fig. 3)

9. Antique the beads by painting a coat of raw umber over the entire bead, getting the paint into the impressed dots and lines. Wipe the paint off immediately with a paper towel. The brown paint will antique the designs and highlight the facial features. Brush on a tiny bit of brown for the doll's hair. (Fig. 4)

10. Paint two little pink dots for the cheeks and dab them immediately with your fingertip to remove some of the paint. Allow the beads to dry for a few hours before using them to make jewelry.

*Fig. 1*

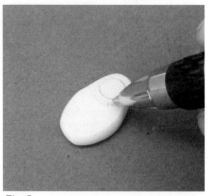
*Fig. 2*

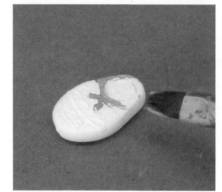
*Fig. 3*

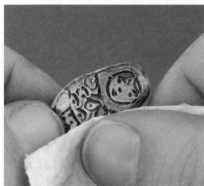
*Fig. 4*

## DESIGNER SPOTLIGHT:
## ◇ HEATHER MILLICAN ◇

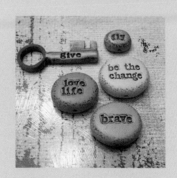

Bead artist **HEATHER MILLICAN** of Swoon Dimples creates polymer-clay word beads that have been antiqued with brown paint like the doll beads in our project. Antiquing textured beads with brown paint brings out all the small details and adds depth to the beads.

# LAB 05   SWIRL DISKS

## TOOLS AND MATERIALS

→ White polymer clay (I used Sculpey III.)

→ 18-gauge wire

→ Bead rack or accordion-folded paper (See Tip opposite.)

→ Baking sheet

→ 800-grit wet/dry automotive sandpaper

→ Baby oil

→ Paper cup or small jar

→ Alcohol inks

→ Paper toweling

→ Soap

→ Water

## TIP

I recommend Sculpey III for this project. Its surface is porous when baked, and it picks up the pigment beautifully.

**MARBLING IS AN AGE-OLD TECHNIQUE THAT'S USUALLY APPLIED TO PAPER.** It's done by floating pigment in water or another liquid, and then running paper through the pigment to pick up the colors. To achieve the marbled effect, the pigment and liquid must not mix. Since baby oil and alcohol inks separate when mixed, they are the perfect pairing for marbling beads.

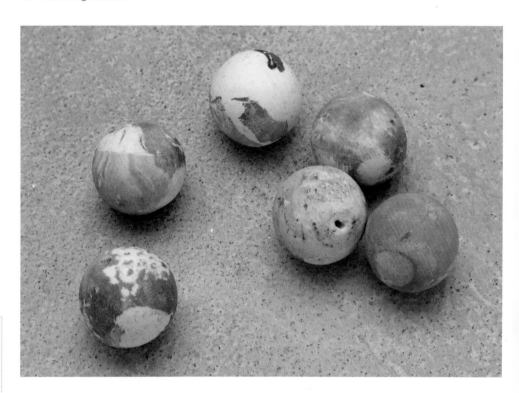

1. Condition the clay and roll a ½" (1.3 cm) ball between your palms. Repeat for as many beads as desired. Use the wire to poke a hole through the beads. Place the beads on wires on a bead rack, leaving space between them. Bake them on a baking sheet according to the manufacturer's directions. Remove them from the oven and allow them to cool completely. (Fig. 1)

2. Sand each bead with a circular motion over the entire surface. (Fig. 2)

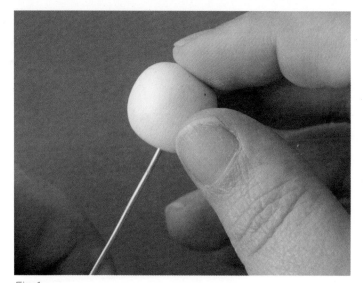

Fig. 1

Fig. 2

Fig. 3

3. Place a bead on the end of a wire or bead mandrel.

4. Pour 2" (5 cm) of baby oil into the paper cup or jar. Add 2 or 3 drops of alcohol ink (1 drop of each color). Swirl the colors gently with another piece of wire.

5. Dip the bead in the oil. Twist the wire as it goes through the ink to grab the color. Remove the bead from the oil and place it on a paper towel to set up for a few minutes. (Fig. 3)

6. Wipe off any excess baby oil with a paper towel. Wash the beads with soap and water and dry with another paper towel.

# LAB 06 WOVEN STRIPES

## TOOLS AND MATERIALS

→ Polymer clay in white plus 2 or 3 other colors

→ Pasta machine or acrylic roller

→ Long tissue blade

→ 18-gauge wire

→ Baking sheet

## TIP

If you are baking many beads at once, place them on 8″ (20.3 cm) wires, leaving a space between each. Suspend the wires from a bead rack so that you can bake all of them at one time.

**THIS PROJECT STARTS BY SLICING AND STACKING STRIPES OF CLAY INTO WHAT'S CALLED A CANE.** The mix of colors runs through the cane, which is cut crosswise into paper-thin slices and applied to beads.

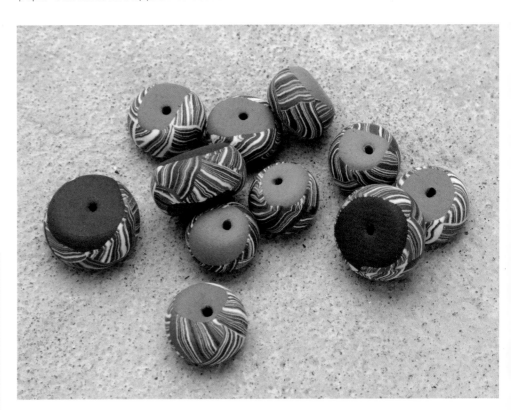

1. Condition the clay. Roll each color into a cylinder shape about 3″ (7.6 cm) long and as thick as a pencil. Place the cylinders next to each other and twist them together. Roll the cylinders together and twist them again. Fold the clay over and roll it again to form a cylinder. Twist the cylinder and fold it over. Roll the clay again and fold it over. (Fig. 1)

2. Shape the folded piece of clay to form a long rectangle. Run the clay through the pasta machine on the thickest setting, inserting the folded end first. Alternatively, use the acrylic roller to press the clay into a 1/8″ (3 mm) -thick slab.

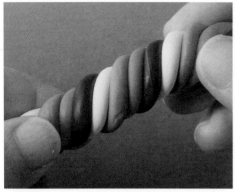

*Fig. 1*

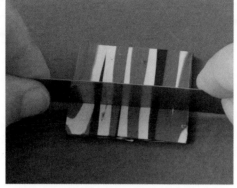

*Fig. 2*

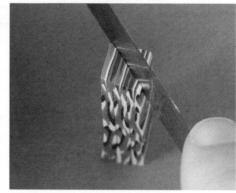

*Fig. 3*

*Fig. 4*

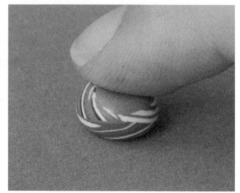

*Fig. 5*

*Fig. 6*

3. Place the slab of clay on your work surface. The clay should be striated vertically. With the long tissue blade, cut a ¼" (6 mm) horizontal length of clay and stack it on stop of the slab. Cut another length and place it on top of the stack. There should be three layers of stacked clay that form stripes. (Fig. 2)

4. Stand the stacked clay on the work surface and use the long tissue blade to slice the stack diagonally through the center into two even triangles. (Fig. 3)

5. Lay the two triangles flat on the work surface and cut them down the middle to create four even pieces.

6. Stack the triangles so that the directions of the stripes alternate. Press the pieces together firmly to form the cane. Use the acrylic roller to roll over the cane. (Fig. 4)

7. Roll a separate color of clay into a cylinder shape as thick as a pencil. Cut the cylinder into ⅜" (1 mm) lengths. Roll the pieces in the palm of your hands into round beads.

8. Slice off a thin cross section of the striped cane. Layer it around the middle of the bead. Roll the bead in the palm of your hand until the seam disappears. (Fig. 5)

9. Place a bead on your work surface and flatten it lightly with the tip of your finger. Flip the bead over and press again. Poke a hole through the bead with the 18-gauge wire. (Fig. 6)

10. Place the beads on the baking sheet and bake according to the manufacturer's directions.

# MILKWEED PODS

## TOOLS AND MATERIALS

→ Polymer clay in light brown, lime green, white, translucent, and dark brown

→ Pasta machine or acrylic roller (See Note.)

→ Long tissue blade

→ Toothbrush

→ Rounded sculpting tool or darning needle

→ Short piece of 18-gauge wire

→ Baking sheet

→ Acrylic paint in brown and metallic moss green

→ Paintbrush

→ Water

→ Paper toweling

→ 400-grit wet/dry sandpaper

→ Microcrystalline wax (I used Renaissance wax)

*Note: Either use the pasta machine as directed or roll clay with an acrylic roller to the indicated thickness.*

**THESE NATURE-INSPIRED BEADS ARE MADE WITH MULTICOLORED CANES.** Layered, wrapped, and textured, the beads are not hard to make, but they do take time.

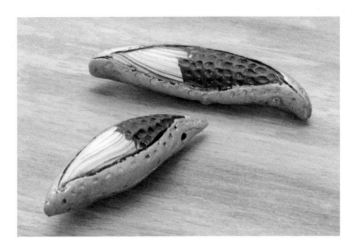

1. Condition the clay. Mix a 1:8 ratio of light brown and lime green for the outside of the pods. No more than one-quarter of a 1.97 ounce (56 g) block of clay is needed for the lime green.

2. Roll the white and translucent clay into two pencil-thick cylinders about 3" (7.5 cm) long. Roll the two cylinders into one. Twist, fold, and roll it again. Repeat two or three times. Fold the clay over. Feed it though the pasta machine on the thickest setting (about 1/8" [3 mm]), inserting the folded end first.

3. Use the tissue blade to cut a 1/4" (6 mm) horizontal section of the clay and layer it on top of the uncut clay rectangle. Repeat three more times to create a striped cane. Turn the clay cane on its side so the stripes are vertical and pinch along the top edge of the cane to form a triangle. Set it aside. (Fig. 1)

4. Roll the light brown and dark brown clay separately into cylinders about 3" (7.6 cm) long and 1/8" (3 mm) -thick. Twist the two cylinders together, fold over, and twist again. Roll the cylinders on the work surface to smooth it out. On one side of the cane, pinch the clay to form a teardrop-shaped cane. Set it aside. (Fig. 2)

5. Roll a 1/2" (1.3 cm) ball of dark brown clay between your palms. Roll the clay back and forth to form an oval bead.

6. Cut a thin slice of the white/translucent striped cane and place it on the bottom half of the oval bead with the stripes running vertically. Repeat, adding the striped cane to cover the bottom of the bead.

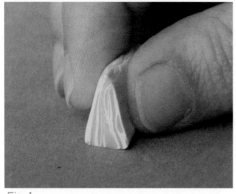

Fig. 1

Fig. 2

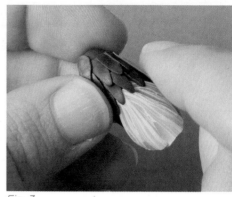

Fig. 3

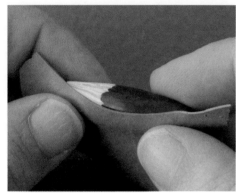

Fig. 4

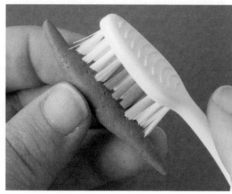

Fig. 5

7. Cut a thin slice of the light-brown teardrop cane and place it at the top of the oval bead. Repeat covering the front part of the bead from the top, working downward in overlapping layers until you reach the white striped canes. (Fig. 3)

8. Roll the bead on the work surface to smooth the overlaps. Taper the ends of the oval by turning your fingers slightly as your roll over the bead.

9. Flatten the mixed green clay in the pasta machine on the thinnest setting. Wrap a piece of the slab around half of the bead. Roll the bead slightly between your palms. To taper the ends of the bead, place the bead on the table and roll over the ends with your fingers angled slightly toward the end of the bead. (Fig. 4)

10. Lightly press the toothbrush bristles on the green part of the bead. Use the sculpting tool to add indents to create a line of small dots vertically along the bead. Repeat several times. Turn the bead over and press even marks on the brown cane area with the sculpting tool, working in horizontal lines across the brown cane area. (Fig. 5)

11. Use the wire to poke a hole horizontally through the top of the bead. Place the beads on a baking sheet and bake according to the manufacturer's directions. Remove from the oven and cool completely.

12. Antique each bead with the brown paint, wiping off the excess with a paper towel. Dry thoroughly. Use a dry brush to apply the metallic green paint on the green areas of the bead. Sand the bead on the front and lightly on the back. Wax the bead with a tiny amount of wax and buff with a paper towel.

# RENAISSANCE RELICS

## TOOLS AND MATERIALS

→ Black polymer clay

→ Cornstarch

→ Acrylic roller

→ 2 rubber stamps

→ 18-gauge wire

→ Baking sheet

→ 2 paintbrushes

→ Liquid polymer clay

→ Silver embossing powder (I used Iced Enamels Relique Powder in German Silver.)

→ Bead rack

→ Acrylic paints in light gray, gold, and black

→ Paper toweling

→ Baby wipes

*Note: These results are dependent on brand-specific embossing powders. Not all embossing powders bond permanently to polymer clay; some will rub off or lose their metallic finish. The two brands I recommend for this project are Ice Resin Iced Enamels and Ranger.*

**RUBBER STAMPS OFFER A SIMPLE WAY TO CREATE A PATTERN ON A POLYMER PENDANT.** By pressing the clay between two rubber stamps, you'll create a double-sided design. A mixed-media treatment with silver embossing powder gives these pendants an ancient look, like found relics. Layers of paint offer a rich patina to enhance the aged feel.

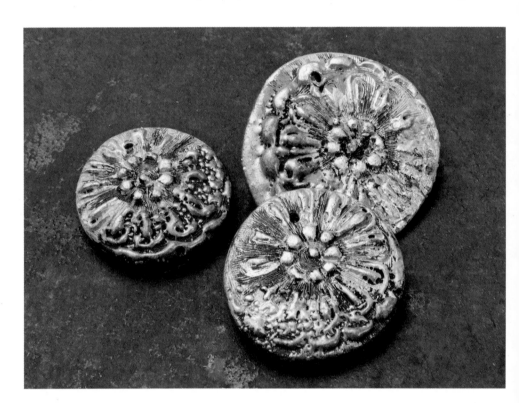

1. Roll a 1 1/4" (3.2 cm) chunk of black clay in your palms to form a ball. Roll the ball in the cornstarch, and then roll it in your hands again. Use the acrylic roller to flatten the ball into a 1/2" (1.3 cm) -thick coin.

2. Press the clay between the two rubber stamps until the coin is 1/4" (6 mm) -thick. With the wire, poke a hole at the top of the pendant. (Fig. 1)

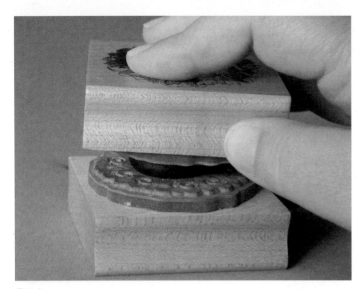

*Fig. 1*

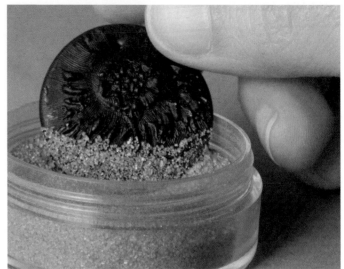

*Fig. 2*

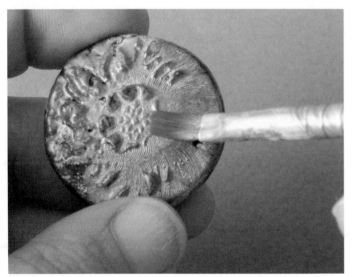

*Fig. 3*

### TIP

After you apply the embossing powders, the pendants must not touch the baking sheet while baking.

3. Place the pendant on a baking sheet. Bake according the manufacturer's directions. Remove from the oven and allow the pendant to cool completely.

4. With a paintbrush, apply a light coat of liquid polymer on the bottom half of the pendant. Dip the pendant into the embossing powder. Hang the pendant from the wire and suspend it on the bead rack. Bake for 10 minutes at 265°F (130°C). Allow it to cool completely. (Fig. 2)

5. With a dry brush, paint a light coat of gray paint on the black clay. Wipe off the excess with a paper towel. Allow it to dry. Repeat with the gold paint, letting some of the gray show through. (Fig. 3)

6. In the center of the pendant, paint the recesses of the design in black. Wipe off the excess with a baby wipe.

# ROSY POSY

## TOOLS AND MATERIALS

→ Two-part molding putty (I used Amazing Mold Putty.)

→ Waxed paper

→ Button

→ Black polymer clay

→ Cornstarch

→ Paintbrush

→ Translucent liquid polymer clay

→ 4 mm pointed-back crystal gems

→ Short piece of 18-gauge wire

→ Baking sheet

→ Acrylic paint

→ Baby wipes

→ Microcrystalline wax (I used Renaissance Wax.)

**THIS PROJECT USES MOLDING PUTTY. IT COMES PACKAGED WITH TWO DIFFERENT SOFT MATERIALS THAT, WHEN MIXED TOGETHER AND ALLOWED TO SET UP, SOLIDIFY TO FORM A MOLD.** Using a mold to create clay beads allows you to whip up multiples of the same design. These sweet rose pendants start with a button to create the molded shape. They are embellished with a small crystal for a touch of bling.

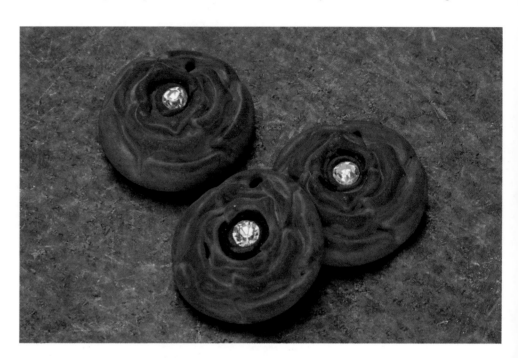

1. Pinch off a 1" (2.5 cm) piece of each of the two parts of the molding putty. Squeeze and fold the materials together to blend them completely. Roll them into a ball.

2. Place the mold material on a sheet of waxed paper covering your work surface. Press the button into the mold material to leave a deep impression. Leave the button in the mold for 10 to 15 minutes until the mold sets. It will be firm to the touch. Pop the button out of the mold. (Fig. 1)

3. Roll a 1" (2.5 cm) piece of black polymer clay in your palms. Roll the ball in the cornstarch and then in your hands again.

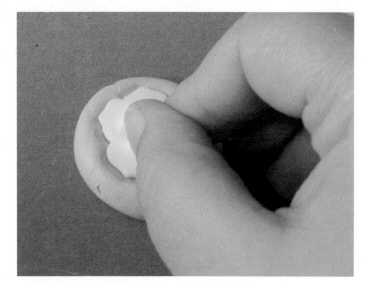

Fig. 1

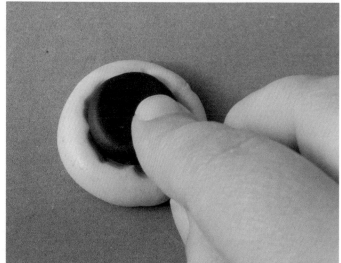

Fig. 2

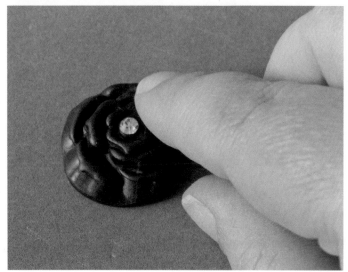

Fig. 3

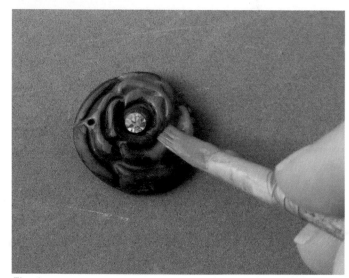

Fig. 4

4. Press the ball deeply into the mold. If the ball of clay is too big, remove a little until it fits inside the mold. Remove the clay from the mold. (Fig. 2)

5. Use a paintbrush to place a small dot of liquid polymer clay in the center of the pendant. Press the crystal into the liquid clay. (Fig. 3)

6. Use the wire to poke a hole at the top of the pendant. Place the pendant on a baking sheet and bake according to the manufacturer's directions. Remove it from the oven and allow it to cool.

7. Paint the pendant with acrylic paint. Rub the paint off the raised areas with a baby wipe. Wipe any paint off the crystal. Allow it to dry. Rub a thin layer of wax over the bead, avoiding the crystal. (Fig. 4)

# CLAIRE MAUNSELL

CANADIAN ARTIST CLAIRE MAUNSELL BEGAN HER CAREER IN HOT GLASS. SHE BUILT HER OWN GLASS-WORKING STUDIO AFTER GRADUATION FROM SHERIDAN COLLEGE SCHOOL OF ARTS AND CRAFTS. WHEN SHE LATER TOOK UP POLYMER CLAY AS A MEDIUM, MAKING HOLLOW FORMS INTO JEWELRY, SHE DISCOVERED HER NEW LOVE HAD MUCH IN COMMON WITH HER WORK IN MOLTEN GLASS.

**Q:** You have such a distinct style in polymer clay. What were some of the turning points for you in finding that style?

**A:** The major turning point for me was when I realized that my twenty-year career as a glassblower was not going to be stifled and forgotten just because I had embraced a new material. My fingers wanted to make the same movements, and my aesthetic had not changed. Once I realized this, it became an extraordinarily rich vein to mine. In glass and clay there are so many obvious parallels in technique and color to explore. I suppose you could say I already had a style developed over twenty years and just returned to it.

**Q:** How has teaching influenced your bead making?

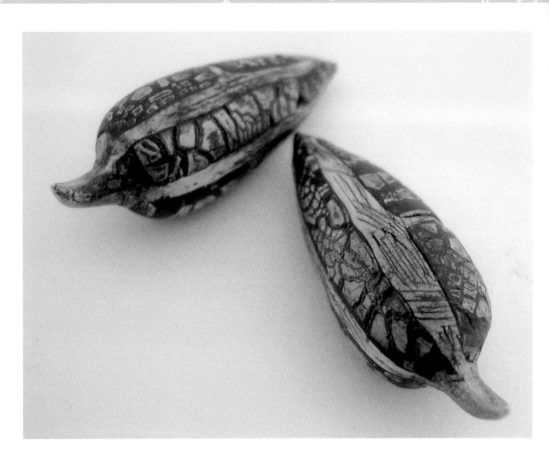

**A:** Perhaps it's made me aware that I have to streamline the creative processes in order to make it understandable. I often work hollow, rather than working with the clay as a solid block. Students can find this difficult to understand. But as I've thought about how to better explain and demonstrate my process, my work has become better and more consistent as well. My only problem—a nice one to have—is that I have too many ideas. I often feel as if I am going madly in all directions at once. It was the same when I worked in glass.

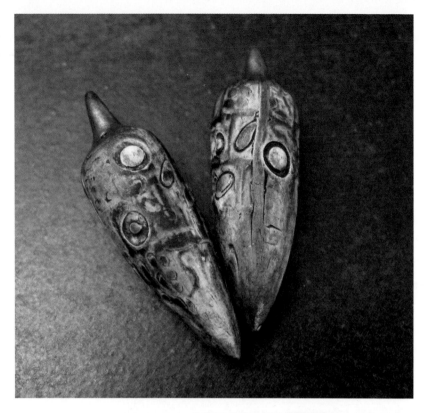

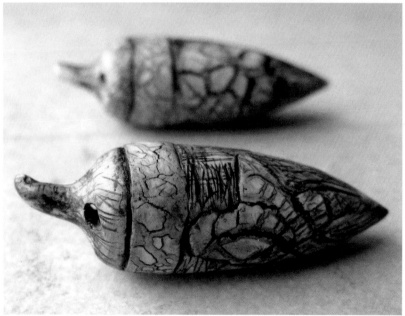

**Q:** What outside inspirations do you bring to your polymer clay creations?

**A:** Of course, the natural world is a huge inspiration. Nature makes design look so easy. But it isn't so simple, as anyone who's ever made anything knows full well. What I also pay attention to is how people make marks. Everyone does this a little differently. I learn a lot by looking at how great artists and craftsmen approach a surface or a form. My great love and inspiration over the past twenty years, in glass as well as clay, has been the artwork of the indigenous people of Australia. I never tire of their approach. It's endlessly inventive, mesmerizing, and, yes, inspiring.

**Q:** What are your favorite unlikely polymer clay tools?

**A:** Lately, it's been paper. It's such a useful tool. I use it to make texture plates, which allow for a huge range of surface possibilities! I'm also fond of my collection of bamboo knitting needles that I was fortunate enough to find at a dollar store. Their surface finish makes a nice change from ordinary dowels. And then there's my "scorp;" it's a wood carving tool—very expensive but useful. You can find it on the Internet if you're curious. And lastly, an extremely stiff close-set wire brush that I found at a welding store. With polymer, the possibilities are endless.

## TOOLS AND MATERIALS

→ Air-dry clay

→ Acrylic roller

→ Wood-grain rubber stamp

→ Short piece of 18-gauge wire

→ Paintbrush

→ Acrylic paint in olive green, teal, and brown

→ Water

→ Paper toweling

→ 800-grit wet/dry automotive sandpaper

→ Microcrystalline wax (I used Renaissance Wax.)

**A WOOD-GRAIN-PATTERNED RUBBER STAMP ALLOWS YOU TO WHIP UP A FOREST OF THESE BEADS.** Paint them in different colors to match any jewelry project. Pair them up with blue bird and nest beads (pages 42 and 134) for a woodland-themed design.

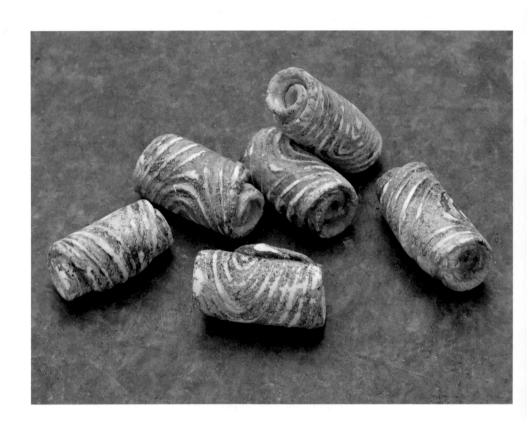

1. Tear off a pea-size piece of clay. Pinch the clay, fold it over, and pinch it again to hydrate the clay. Dip your fingers into water and smooth them over the clay. Roll the bead between your palms until it no longer feels sticky.

2. Shape the bead into a long, narrow oval by rolling it back and forth in your hands.

3. Using the acrylic roller, roll the oval flat. Place the oval on top of the rubber stamp. Press it firmly, then flatten it with the acrylic roller. (Fig. 1)

Fig. 1

Fig. 2

Fig. 3

4. Lift the edge of the clay at one end of the stamp and roll it into a tube shape. Use the wire to poke a hole through the bead. Set the bead aside to dry for 24 hours. It will no longer be cool to the touch when it is completely dry. (Fig. 2)

5. Paint the bead with a light layer of olive green acrylic paint and allow it to dry. Paint it again with a light layer of teal acrylic, allowing some of the green to show through. Allow it

to dry. Paint it a third time with a light wash of brown acrylic paint mixed with water. Wipe off the excess with a paper towel. Allow the bead to dry. Sand the raised areas and seal the bead with wax. (Fig. 3)

## TOOLS AND MATERIALS

→ Air-dry clay

→ Water

→ Mechanical pencil

→ 800-grit wet/dry automotive sandpaper

→ Paintbrush

→ Acrylic paint in floral colors, brown, and metallic gold

→ Paper toweling

**THESE FLOWERS MADE FROM AIR-DRY CLAY ARE SURPRISINGLY TOUGH, BUT DON'T MAKE THE PETALS TOO THIN.** Paint the beads in your favorite colors, embellishing the outside of the flowers, too. Use the hole in the bead as a design element to attach it to jewelry or add a small hole on the back of the bead for stringing projects.

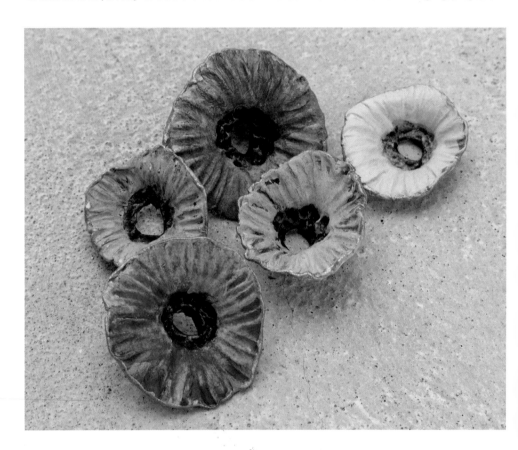

1. Tear off a pea-size piece of clay. Pinch the clay, fold it over, and pinch it again to hydrate it. Dip your fingers in water and smooth them over the clay. Roll the bead in your palms until it no longer feels sticky.

2. Pinch the bead to shape it into a dome. Pinch along the edge to thin out the dome's wall.

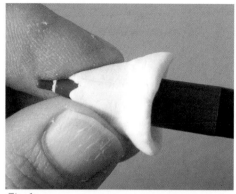
*Fig. 1*

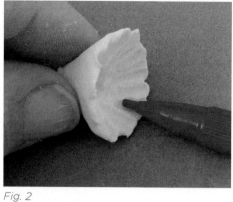
*Fig. 2*

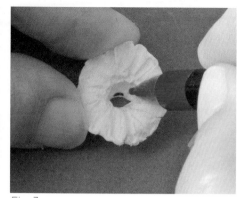
*Fig. 3*

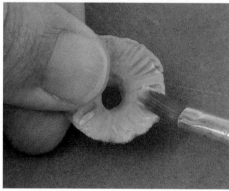
*Fig. 4*

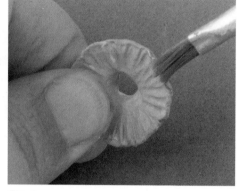
*Fig. 5*

3. Insert the point of a mechanical pencil in the center of the dome until it pokes through, forming the flower. Pinch the clay around the pencil to lengthen the shape of the flower. Push the pencil through to make the hole wider. Remove the flower from the pencil and fold the edge over at the top (the narrower part of the bead). (Fig. 1)

4. Gently lay the flower on its side on your work surface. Make petal marks on the inside of the flower with the mechanical pencil (with the lead retracted), incising a line from the center of the flower to the outer edge. Repeat along the inside of the flower, rotating it as you go. (Fig. 2)

5. Turn the flower dome side down and fold the petals gently downward. On the inside of the flower, use the mechanical pencil to create dots in two rows around the center opening. (Fig. 3)

6. Set the flower aside to dry for at least 24 hours. The clay will no longer feel cool to the touch when it's completely dry. Sand off any fingerprints or imperfections.

7. Paint the flowers in floral colors on all sides and allow the paint to dry. (Fig. 4)

8. Paint on a thin wash of watered-down brown on the inside center of the flower, wiping off the excess paint with a paper towel. Paint along the outer edge of the flower petals with metallic gold paint. (Fig. 5)

# LAB 12 TINY HOUSES

## TOOLS AND MATERIALS

→ Air-dry clay

→ Water

→ Acrylic roller

→ Darning needle

→ 18-gauge wire

→ 800-grit wet/dry automotive sandpaper

→ Paintbrush

→ Acrylic paints

→ Water

→ Paper toweling

→ Microcrystalline wax (I used Renaissance wax.)

## TIP

Poke the hole starting at the top of the house down through the base.

**THESE TINY HOUSES MADE WITH AIR-DRY CLAY MIMIC THE LOOK OF CERAMICS.**
Embellish both sides of the house and add windows for variation.

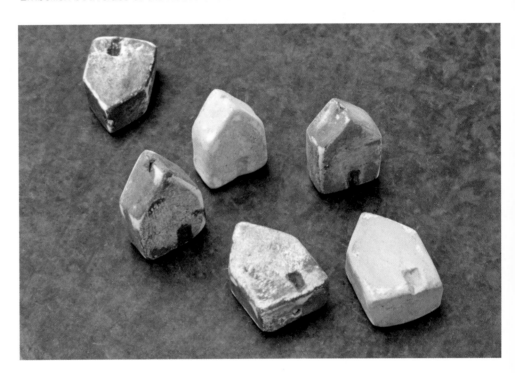

1. Tear off a ½" (1.3 cm) piece of clay. Pinch the clay, fold it over, and pinch again to hydrate the clay. Dip your fingers in water and smooth them over the clay. Roll the bead between your palms until it's no longer sticky.

2. Pinch the clay to flatten it slightly. Pinch one side to form the peaked roof of the house. Pinch and flatten the lower section of the house into a square. (Fig. 1)

3. Use the acrylic roller to flatten the bead lightly and evenly. Turn the bead over and repeat. The bead should be at least ¼" (6 mm) -thick. Use the rounded end of the darning needle to impress a small rectangle on the front of the house for the door. (Fig. 2) Poke a hole through the bead vertically with the wire.

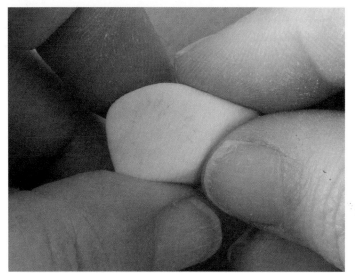

Fig. 1

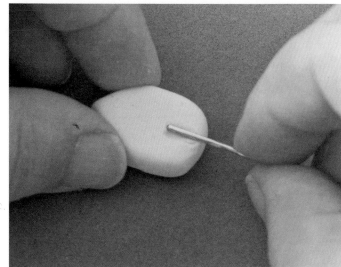

Fig. 2

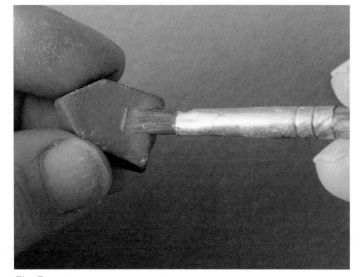

Fig. 3

Fig. 4

4. Allow the clay to dry for at least 24 hours. When it is completely dry, it will no longer feel cool to the touch.

5. Lightly sand the surface the bead.

6. Paint the bead with a wash of brown acrylic paint thinned with water. Allow it to dry completely. Paint a light layer of a brighter color over the bead. Wipe off the excess paint with a paper towel and allow it to dry. (Fig. 3)

7. Sand the edges of the beads to create a distressed look. Seal the bead with a light layer of wax. (Fig. 4)

# BLUE BIRDS
## OF HAPPINESS

## TOOLS AND MATERIALS

→ White air-dry clay

→ Water

→ 4″ (10.2 cm) piece of 18-gauge wire

→ 400-grit sandpaper

→ Paintbrush

→ Acrylic craft paint (I used teal and light gray.)

→ Black fine-point permanent marker

**FORM THESE FOLK-INSPIRED BIRDS BY HAND. THE AIR-DRY CLAY DRIES OVERNIGHT INTO A ROCK-HARD FINISH.** Create a whole flock of birds in bright colors to string together for a playful necklace.

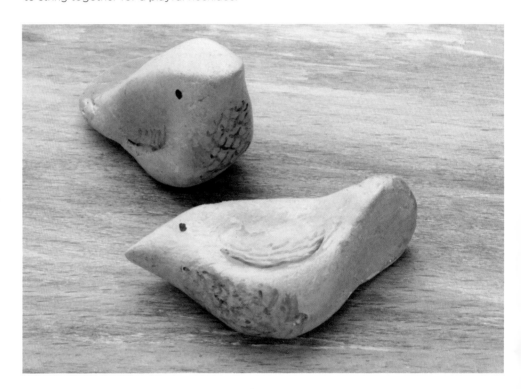

1. Pinch off a ¾″ (2 cm) piece of clay. Roll the clay gently between your palms to form a ball.

2. Pinch the clay to form a rectangle. Pinch one end to form the tail. Pinch the tail flat, widening the end of the tail.

3. Pinch the other end of the clay to form the beak. (Fig. 1)

4. Smooth out any rough areas with your fingertips. Work quickly to form the bead. If the bead starts to dry out too much, dip your fingertips in water and smooth them over the clay. Use the wire to poke a hole horizontally through the bead.

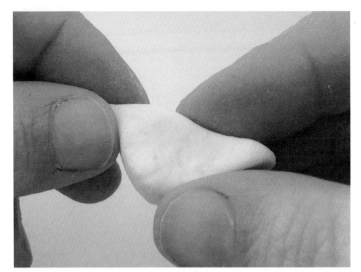
Fig. 1

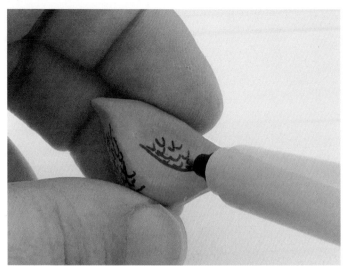
Fig. 2

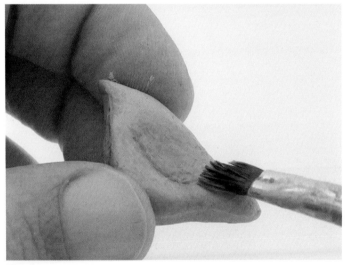
Fig. 3

5. Let the bead dry overnight. It will be completely solid when it's dry and no longer cool to the touch. Sand the surface lightly.

6. Paint the entire bead with teal-colored paint. Allow the paint to dry thoroughly.

7. Draw feathers on the wings, chest, and tail with the marker. Allow the ink to dry. (Fig. 2)

8. Brush gray paint over the entire bead, leaving the teal showing on the tail, wings, and chest. Allow the paint to dry. (Fig. 3)

9. Draw the bird's eyes with the marker.

# GOLDEN OWLS

## TOOLS AND MATERIALS

→ Paper clay

→ Water

→ Acrylic roller

→ Mechanical pencil

→ 4" (10.2 cm) piece of 18-gauge wire

→ Alcohol inks (I used Adirondack Alcohol Ink by Ranger in Stream, Wild Plum, and Violet.)

→ Paintbrush

→ Plastic container lid or palette for alcohol inks

→ Latex gloves or pumice soap and scrubbing sponge (optional)

→ Gold oil-based permanent-paint marker (I used a Sharpie.)

## TIP

Alcohol ink is very difficult to remove from your fingers. Wear thin latex gloves or use pumice soap and a scrubbing sponge to remove it from your fingers immediately.

**INSPIRED BY JEWELED CREATIONS FROM INDIA, THESE COLORFUL OWL BEADS ARE DECORATED WITH A METALLIC MARKER FOR A GILDED LOOK.** This project uses paper clay, which lets the bright alcohol inks glow with a painterly look. A mechanical pencil is the perfect tool for marking the beads. Pair up these beads with a thread tassel for a cute necklace.

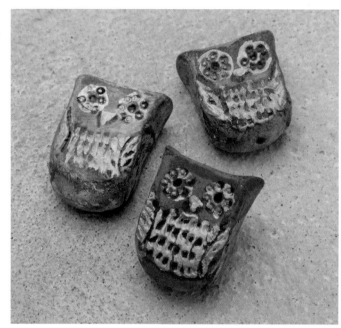

1. Tear off a 1" (2.5 cm) piece of clay. Pinch it, fold it over, and pinch it again to hydrate the clay. Dip your fingers in water and smooth them over the clay. Roll the bead in your palms until no longer sticky.

2. Shape the clay into an oval. Flatten the oval to a ½" (1.3 cm) thickness.

3. Pinch the sides at the top of the oval to form a triangular head. (Fig. 1)

4. Set the bead on your work surface. Flatten the bead lightly, using the acrylic roller.

5. Use the mechanical pencil (lead retracted) to poke holes for the eyes. Make lighter holes around the eyes, in a petal pattern. (Fig. 2)

6. Using the tip of the pencil with the lead retracted, draw a small V-shaped beak between the eyes.

7. Use the tip of the pencil to press downward stokes for the feathers on the owl's breast. Work the strokes for the feathers in straight lines across the breast. (Fig. 3)

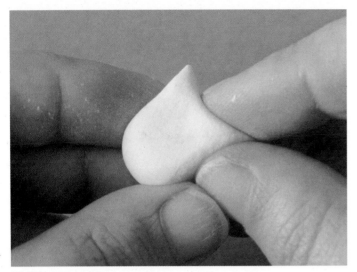

Fig. 1

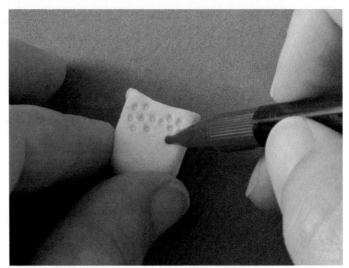

Fig. 2

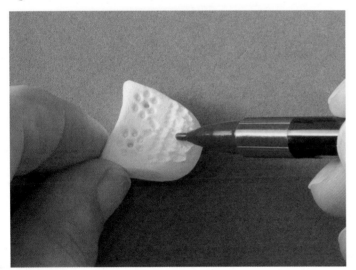

Fig. 3

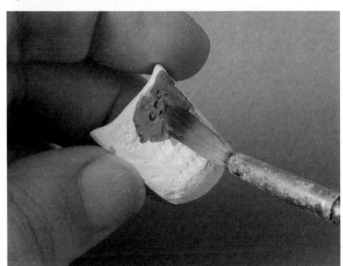

Fig. 4

8. To draw the owl's wings, use the pencil tip to make an oval that begins on the left front of the owl and continues over the edge to the left side. Repeat on the right side. Texture the inside of the wings using the tip of the pencil and downward strokes to create feathers.

9. Poke a hole vertically through the owl with the wire. Allow the clay to dry completely, at least 24 hours. The clay will no longer feel cool to the touch when it's dry.

10. Place a few drops of alcohol ink on the plastic lid. Brush the ink over the surface of the owl. Allow it to dry completely. (Fig. 4)

11. Use the gold marker to highlight the eyes, feathers, and wings. Use the tip of the marker with a light touch to enhance the raised surfaces. Let the bead dry completely before handling it again.

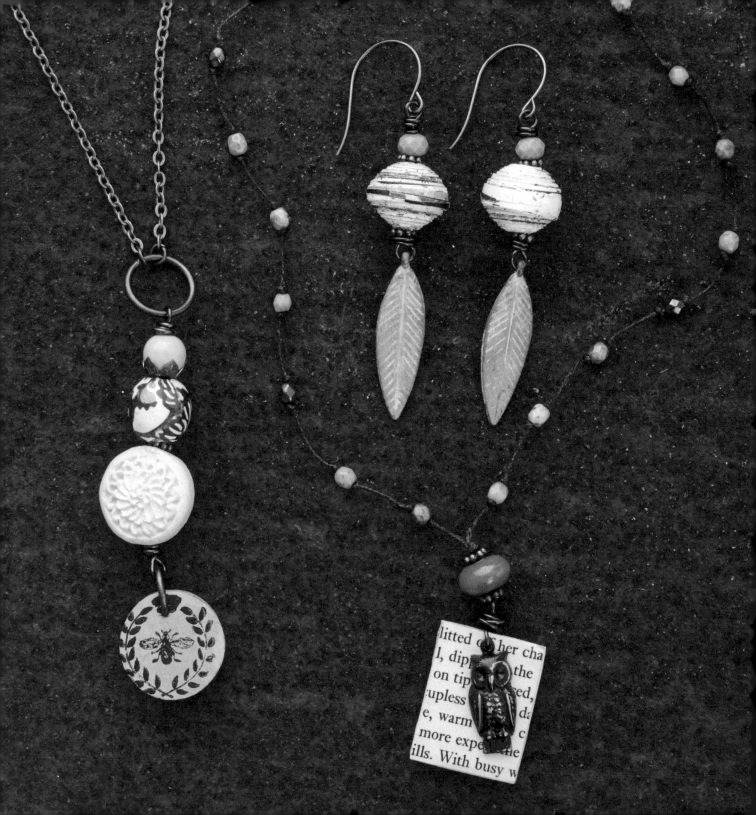

# UNIT
# 02

# PAPER AND CORK

## PAPER BASICS

Paper is lightweight and available in endless colors and patterns. It provides a great means for adding an earth-friendly spin to your jewelry creations. Used in bead making, paper needs to be properly sealed to make it durable and wearable. Some projects use stronger materials—such as wooden beads, blanks, or metal—as a base for delicate paper. Other projects rely on sealers to protect and strengthen the paper.

There are many different sealers on the market. They come in different finishes from matte to ultra-glossy, which will affect the look of the finished piece. My go-to sealer is Mod Podge, which is available everywhere and familiar to anyone who does decoupage and paper crafting.

You can substitute any paper for the selections used in this chapter's projects. Get creative with newspapers printed in other languages. Upcycle old books, comics, magazines, maps, and greeting cards. Use decorative tissue paper, origami paper, wrapping paper, or even printed napkins for decoupage projects.

# DECO BEADS

## TOOLS AND MATERIALS

→ Origami paper

→ Paintbrush

→ Quick-drying tacky glue

→ Unpainted wooden beads

→ 8" (20.6 cm) piece of 15-gauge wire

→ Super-gloss sealer (I used Mod Podge.)

→ Styrofoam block

→ 400-grit sandpaper

## TIP

When tearing the paper, tear downward from the top of the pattern for best results.

**FOR THIS PROJECT, ORIGAMI PAPER IS USED TO CREATE A GRAPHIC PATTERN ON PLAIN WOODEN BEADS.** Tear off the straight edges of the paper and the seams will bend together. Make beads in varying sizes for unique focal points in a necklace.

1. Tear one sheet of paper into small pieces of varying sizes. You'll need larger pieces for the widest part of each bead and smaller pieces to work near the hole. A large piece should be about ¼" (6 mm) wide.

*Fig. 1*

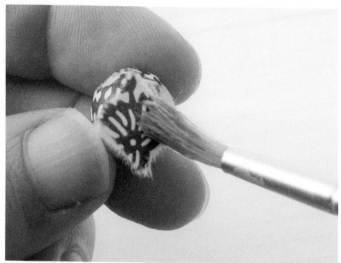
*Fig. 2*

*Fig. 3*

2. Work in small sections starting near the hole in the bead. Brush a thin coat of glue onto the wood and press a piece of paper into place. Smooth the edges of the paper using your fingertips. (Fig. 1)

3. Repeat, overlapping the edges of the bits of paper around the hole at the top and bottom of the bead. Then use the larger pieces of paper to cover the center section of the bead. (Fig. 2)

4. Thread the bead onto an 8″ (20.5 cm) piece of wire. Fold the ends of the wire over to make a U shape. (Fig. 3)

5. Holding the ends of the wire with one hand, brush the super-gloss sealer onto the bead with the other. Press the ends of the wire into the block of Styrofoam to hold the bead while it dries.

6. When the bead is dry, sand it lightly.

# COLOR BLOCK
## PENDANTS

## TOOLS AND MATERIALS

→ ⅛" (3 mm) -thick cardboard

→ Scissors

→ Newspaper

→ White craft glue

→ Dish or saucer

→ Water

→ Paintbrush

→ Hair dryer (optional)

→ Matte sealer (I used Mod Podge.)

→ 400-grit sandpaper

→ Rotary tool with 2 mm drill bit

→ Acrylic paint in white plus 2 other colors

→ Washi tape or painter's tape

→ Paper towels

**CREATE THESE MODERN COLOR-BLOCK PENDANTS FROM THE SIMPLEST MATERIALS.** They have such a trendy feel—hard to believe they're made from cardboard and newspaper. The sky is the limit when it comes to geometric shapes. And why stop with pendants? You can drill horizontally through the shapes to turn them into beads, too. Go big and bold; these shapes weigh next to nothing!

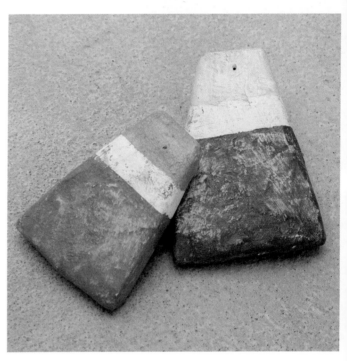

1. Cut the desired shape out of cardboard with scissors.

2. Tear newspaper into small strips of varying lengths and widths.

3. Pour a small amount of glue into the dish and add a few drops of water to thin it. (Start with a 1" [2.5 cm] puddle of glue and two or three drops of water.)

4. Paint the glue mixture on both sides of one of the longer strips of paper. Wrap the strip around the cardboard cutout. Smooth the seams with your fingertips. (Fig. 1)

5. Repeat, covering the entire pendant in a single layer. Use smaller pieces to cover the corners. (Fig. 2)

6. Let the first layer dry completely. Use a hair dryer to speed up the drying time if desired. Repeat step 4 for a second layer, alternating the direction of the newspaper. Allow the layer to dry completely. Repeat for a third layer.

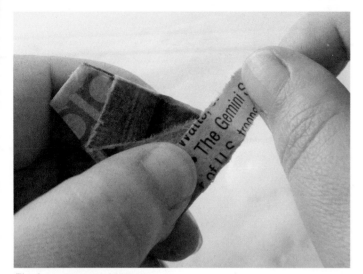
Fig. 1

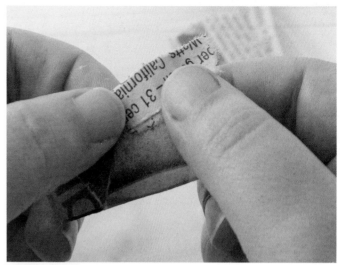
Fig. 2

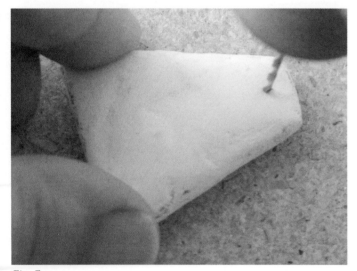
Fig. 3

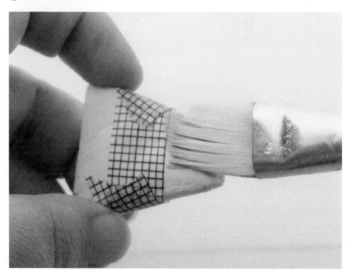
Fig. 4

7. Paint an even coat of matte sealer over the entire bead. Allow it to dry. (I placed my beads on a baking sheet in the oven at 150°F [66°C] for 20 minutes to dry them quickly.) Sand the pendant and repeat with another layer of matte sealer.

8. With the rotary tool, drill a hole at the center of the top of the pendant. Sand the surface again. Paint the entire surface with white acrylic paint. (Fig. 3)

9. Use washi tape to cover portions of the bead that will not be painted. Choose a color and paint an even coat of acrylic on the pendant. Allow it to dry. Paint another coat and wipe off the excess with a paper towel. Let the paint dry. Remove the tape and repeat the painting process on the other end of the pendant with a second color. (Fig.4)

10. Seal the paint with matte sealer. Allow it to dry completely. Repeat with a second coat.

# MAP PENDANTS

## TOOLS AND MATERIALS

→ Recycled or new maps

→ Scissors

→ 1 ¼" (3.2 cm) wood blank

→ Quick-drying glue

→ Matte sealer (I used Mod Podge.)

→ Crackle glaze (I used Crackle Accents by Ranger.)

→ Paintbrush

→ Acrylic paint (I used teal.)

→ Baby wipe

→ Scrap wood block

→ Pencil

→ Rotary tool with 2 mm drill bit

→ 400-grit sandpaper

## TIP

Check the glaze after 2 hours. If the edges of the paper have lifted, re-glue them and add a small amount of glaze along the edge to seal it again.

**CREATE A PENDANT FEATURING A MAP OF YOUR HOMETOWN OR DREAM VACATION SPOT.** Add an interesting texture with a crackle glaze highlighted with paint to mimic the lines of a street map.

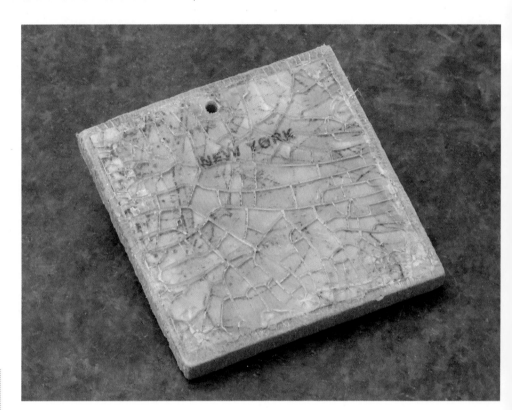

1. Cut out a section of map slightly smaller than the wood blank. Glue the paper to the blank. Allow it to dry. (Fig. 1)

2. Seal the surface of the map with matte sealer. Allow it to dry completely.

3. To avoid air bubbles in the glaze, turn the bottle of crackle glaze upside down and let the liquid fall to the bottom. Do not shake the bottle. Starting along the outside edge of the wood blank, draw a bead of glaze along one edge. Repeat on the other three sides. (Fig. 2)

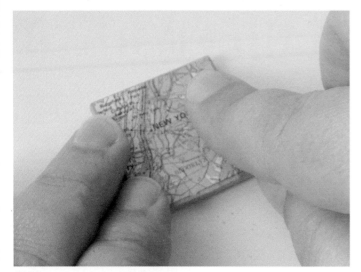

*Fig. 1*

*Fig. 2*

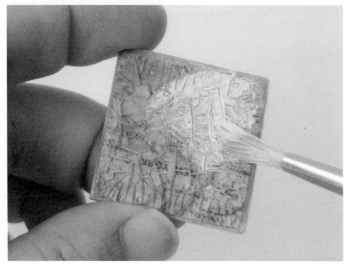

*Fig. 3*

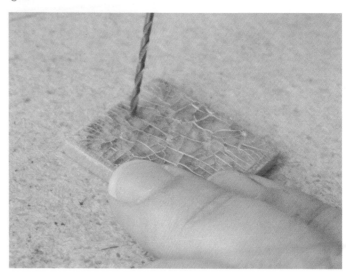

*Fig. 4*

4. Fill in the pendant with the glaze, squeezing thick lines evenly across the pendant. If there are any spots not covered, touch up with a small amount of glaze. Let the glaze dry for 3 to 4 hours to properly crackle.

5. Brush a thin layer of acrylic paint over the glaze, making sure it goes into the cracks. Quickly wipe off the excess paint on the surface with a baby wipe. (Fig. 3)

6. Place the pendant on the scrap wood block. Decide where you want the hole to go and mark the spot with a pencil. Slowly drill through the pendant. Use a small piece of sandpaper to sand the rough edges near the hole. (Fig. 4)

# PAPER SAUCER BEADS

## TOOLS AND MATERIALS

→ Ruler

→ Pencil

→ Magazine pages

→ Craft knife

→ Metal ruler or straightedge

→ Toothpicks

→ Paintbrush

→ Craft glue

→ Glossy sealer (I used Mod Podge Super-Gloss Brilliant.)

→ Paper cutter or scissors

→ Foam block

*Note: A paper cutter helps produce uniform strips and better beads, but you can cut the strips by hand with a craft knife and metal ruler.*

**WANT BEADS THAT HELP SAVE THE PLANET?** Give new life to old magazine pages by using thin-cut strips rolled into beads. Look for magazines with bright and colorful pages for best results.

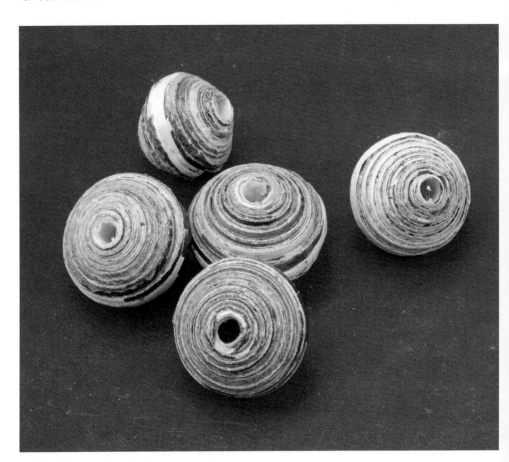

1. With the ruler, mark every ¼″ (6 mm) along one vertical edge of a magazine page. Repeat on the opposite edge. Make additional marks on this second edge, staggered ⅛″ (3 mm) from the measurements along the first edge, so that you get a triangular shape when you connect them with a pencil.

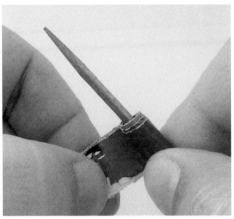

Fig. 1

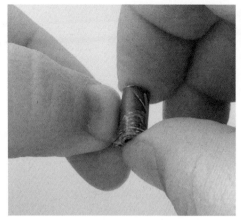

Fig. 2

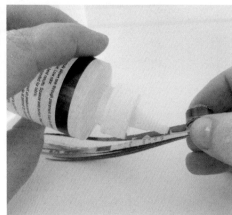

Fig. 3

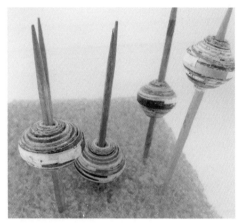

Fig. 4

Fig. 5

2. Use the marks as a guideline to cut out long triangles with a ¼" (6 mm) base. Cut several magazine pages into triangles before rolling the beads.

3. Stack 10 to 15 triangles, carefully lining up the edges. Place a toothpick horizontally across the straight ¼" (6 mm) edge of the stack. Roll all of the layers together around the toothpick several times. (Fig. 1)

4. Remove the toothpick and use your thumb to hold the layers together tightly while pulling on the roll to tighten. (Fig. 2)

5. Continue rolling, keeping the rolled bead aligned in the center, until a 2" (5 cm) tail remains. Apply a bead of glue along the topmost layer of the stack. Wrap it around the rolled bead. (Fig. 3)

6. Continue adding glue at the end of each layer. Attach it to the bead. (Fig. 4)

7. Place the bead on a toothpick and brush glossy sealer over the surface. Allow the bead to dry before turning it over and brushing glossy sealer on the opposite side. Allow the sealer to dry completely. (Fig. 5)

# PAPER PATCHWORK
## PENDANTS

## TOOLS AND MATERIALS

→ 12" (30.5 cm) sheet of scrapbook paper

→ Paper cutter or metal ruler and craft knife

→ Marker

→ Toothpicks

→ Quick-drying glue

→ Matte sealer (I used Mod Podge.)

→ Paintbrush

→ Styrofoam block

**THE BEST PAPER FOR THIS PROJECT IS DOUBLE-SIDED WITH A MULTICOLORED DESIGN.** That will provide a wide range of colors as the paper is rolled. Make large and smaller beads with varying numbers of rolled layers.

1. Cut ¼ x 12" (6 mm x 30.5 cm) strips from the scrapbook paper. Fold each strip in half lengthwise. Use the side of the marker to press along the fold. (Fig. 1)

2. Place a toothpick across one end of a strip. Start winding the strip around the toothpick. Wind the paper tightly until a 1" (2.5 cm) tail remains. Squeeze a little glue along the tail. Wrap and press it firmly in place on the bead. Remove the bead from the toothpick. (Fig. 2)

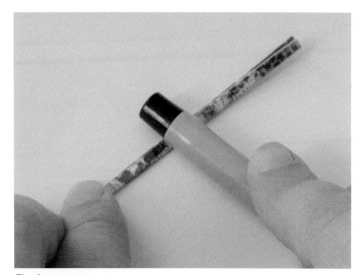

Fig. 1

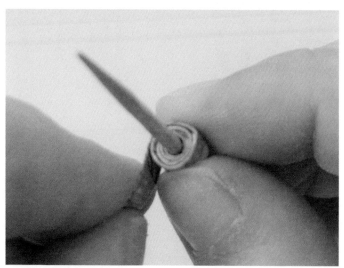

Fig. 2

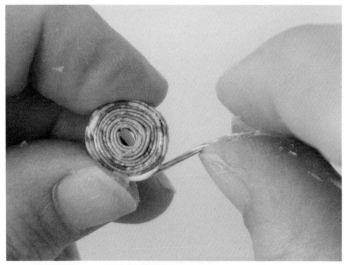

Fig. 3

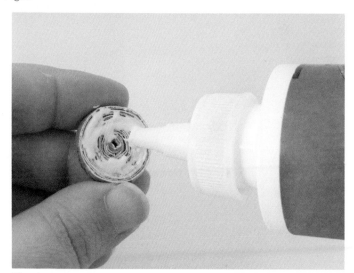

Fig. 4

3. Squeeze a line of glue around the outside of the bead. Start winding a second strip of folded paper around the first, holding it in place to set the glue as you go along. Continue rolling the paper tightly. Glue at the end as in step 2. (Fig. 3)

4. Repeat, adding a third strip of folded paper where the last layer ended.

5. Create another rolled bead. Stack and glue the two beads together, pressing them tightly until the glue starts to dry. (Fig. 4)

6. Coat the bead completely with matte the sealer and place it on a toothpick stuck in the Styrofoam block to dry.

## TOOLS AND MATERIALS

→ Paper cutter (See Note.)

→ Book pages

→ Metal ruler

→ Craft knife

→ Toothpicks

→ Quick-drying glue

→ Paintbrush

→ Glossy sealer (I used Mod Podge, Super-Gloss Brilliant.)

→ Styrofoam block

*Note: If you don't have a paper cutter, use the metal ruler and craft knife to measure and cut the strips.*

**START WITH AN INSPIRING BOOK FOR THESE BEADS.** Love or nature poems work well with romantic jewelry themes.

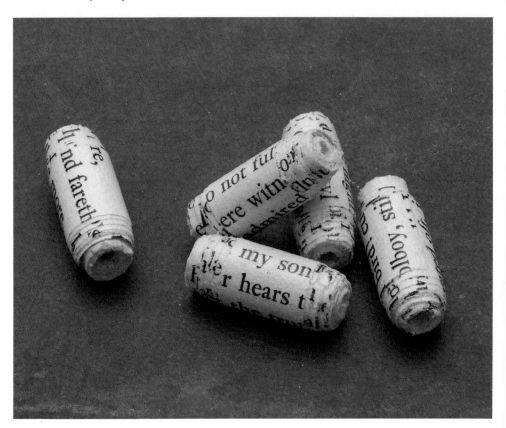

1. Cut the margins of the book pages into ¾" (2 cm) -wide strips. Set them aside. Cut the printed area of the pages vertically into tapered narrow strips that are ¾" (2 cm) wide at one end and ½" (1.3 cm) wide at the other.

2. With the craft knife, trim any remaining margins from the ends of the tapered narrow strips. The words at that end of the strip will be visible on the bead, so plan accordingly. Trim the strip to end on an interesting word. (Fig. 1)

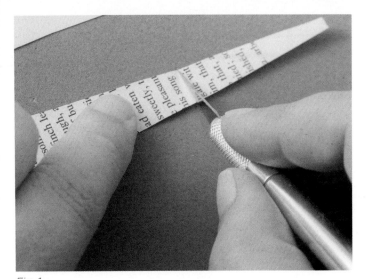

Fig. 1

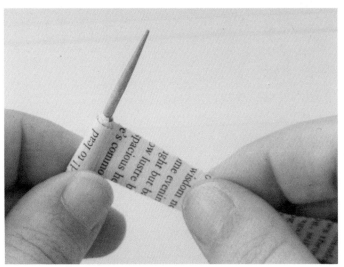

Fig. 2

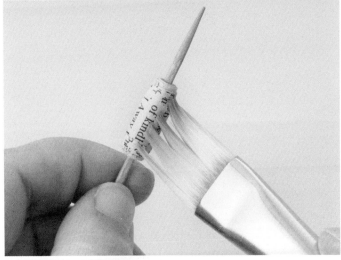

Fig. 3

3. Wrap one of the blank margin strips around a toothpick until a 1″ (2.5 cm) tail remains. Glue the tail in place, pressing it firmly until the glue sets.

4. Apply glue around the outside of the bead. Select one of the tapered strips. Starting with the wider end, wrap it around the bead, pressing it into place until the glue sets up. Continue wrapping the strip tightly until a 1″ (2.5 cm) tail remains. (Fig. 2)

5. Glue the tail into place and press it firmly until the glue sets. Remove the bead from the toothpick.

6. Place the bead on the end of a fresh toothpick and coat it with glossy sealer. Poke the toothpick into the Styrofoam block and allow the sealer to dry completely. (Fig. 3)

# FAUX COPPER
## PENDANTS

## TOOLS AND MATERIALS

→ Pencil

→ Circle templates (See Note.)

→ Scissors

→ Watercolor paper

→ Paintbrushes

→ Matte sealer (I used Mod Podge.)

→ Small hole punch (¹⁄₁₆″ [1.6 mm])

→ Acrylic paint (I used copper, dark teal, and turquoise.)

→ 34 mm metal blank

→ 7 mm jump ring

→ 2 chain-nose pliers

*Note: If you don't have a circle template, use two different-sized bottles to trace your circles.*

## TIP

Always open and close jump rings by pushing the sides back and forth with jewelry pliers; never pull the jump ring open.

**PAINTING A FAUX COPPER PATINA ON WATERCOLOR PAPER OFFERS A QUICK AND EASY WAY TO GET THE LOOK OF METALWORK WITHOUT THE TOOLS AND CHEMICALS.** The paper is well protected with the paint and sealer, but I paired these pendants with metal blanks for extra strength.

1. Cut a 1″ (2.5 cm) and a 1 ½″ (3.8 cm) circle from the watercolor paper. Seal the paper by painting on a thin coat of matte sealer. Allow it to dry. (Fig. 1)

2. Use the hole punch to create a pattern of dots evenly over the surface of the smaller circle. (Fig. 2)

3. Brush the copper paint on the top surface of both circles. Allow the paint to dry. Turn the circles over and paint the second side.

4. With a dry brush, brush a thin layer of dark teal paint lightly over the surface of one of the circles. Allow some of the copper paint show through. Let the paint dry. Turn the circle over and repeat on the opposite side. (Fig. 3)

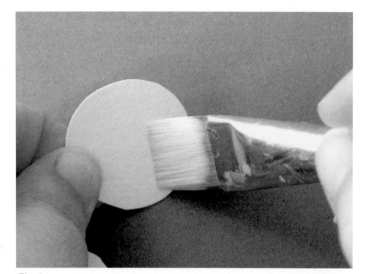

Fig. 1

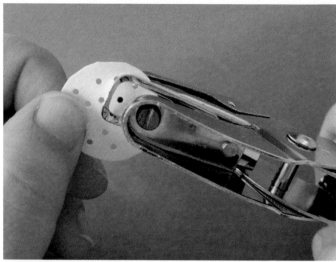

Fig. 2

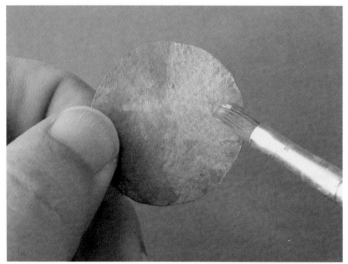

Fig. 3

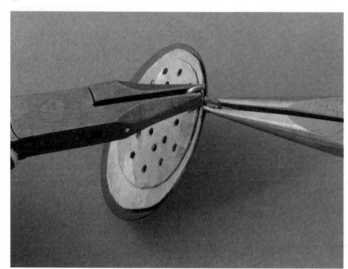

Fig. 4

5. Repeat step 4 with the lighter turquoise paint, allowing both the darker color and copper to show through in areas, to mimic patina. Allow the paint to dry completely. Repeat steps 4 and 5 with the other paper circle, painting in the same way.

6. Seal the surfaces of both circles with matte sealer on both sides. Allow it to dry.

7. Punch a hole in the top of the larger circle.

8. Stack the metal blank, the large circle, and the small circle on top of one other, lining up the three holes. Open the jump ring with jewelry pliers and insert it through all three holes. Close the jump ring. (Fig. 4)

# STACKED BEADS

## TOOLS AND MATERIALS

→ Book pages

→ Pencil

→ Craft knife with a new blade

→ Metal ruler

→ Paintbrush

→ Matte sealer
(I used Mod Podge.)

→ Scrap wood block

→ Rotary tool with 2 mm drill bit

→ 400-grit sandpaper

## TIP

Only the top and bottom layer need to have words; the interior part of the bead can be made with the margins of the book.

**THESE MINIATURE STACKS OF PAPER ARE AN AWESOME WAY TO RECYCLE OLD BOOKS.** Pair them up with small charms, like the Golden Owl charms on page 44, for a very bookish inspiration. Get creative with where the words are cut for the top layer; look for phrases or words that mean something to you. You could also incorporate small images onto your beads.

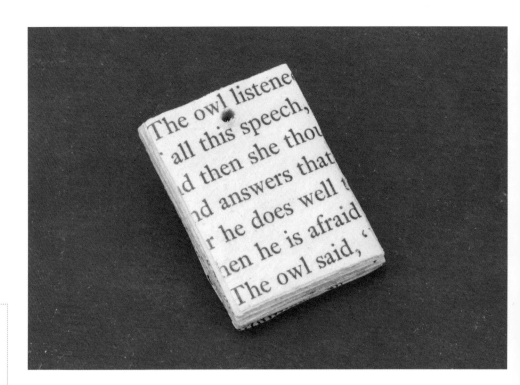

1. Cut a ¼" (6 mm) -thick stack of the book pages to the desired size. I cut mine into ⁷⁄₈" x 1 ⅛" (2.2 x 3 cm) rectangles. (Fig. 1)

2. Create the inside section of the bead. Brush a thin layer of matte sealer on one of the tiny rectangles. Put a second rectangle on top, pressing the two to seal them securely. Continue adding rectangles until the stack is ³⁄₁₆" (4.8 mm) -thick.

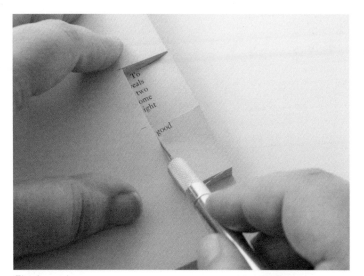

Fig. 1

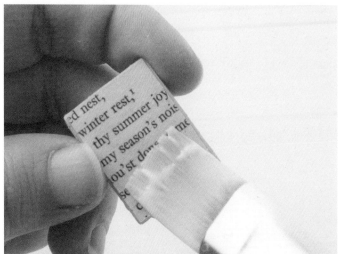

Fig. 2

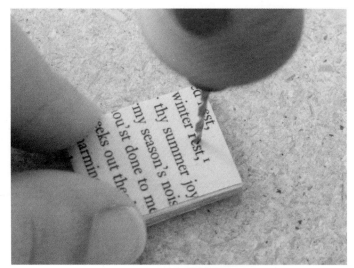

Fig. 3

3. Select two rectangles of paper with words that you like for the top and bottom layers of the bead. Use matte sealer to glue them into place. Allow the stack to dry completely. (Fig. 2)

4. Brush a layer of matte sealer over the entire bead. Allow it to dry.

5. Place the bead on the scrap wood block and, using the pencil, mark where you want to place the hole. Use the rotary tool to slowly drill through the pendant. Use a small piece of sandpaper to sand the rough edges near the hole. (Fig. 3)

# LAB 23 · CORK COINS

## TOOLS AND MATERIALS

→ Bottle corks

→ Small hacksaw

→ 400-grit sandpaper

→ Paintbrush

→ Acrylic paint (I used Martha Stewart Crafts Multi-Surface Satin in Sweet Potato and Yellow Jacket.)

→ 2 small rubber stamps

→ Permanent ink pad (I used StazOn Ink in Black.)

→ Scrap block of wood

→ Pencil

→ Handheld drill or rotary tool with 2 mm drill bit

**THESE BEADS ARE MADE FROM SLICED ROUNDS OF BOTTLE CORKS.** Don't worry if you don't have any old ones, you can find them easily at craft stores. Cork is super lightweight, making these coins perfect for earrings. Use two different rubber stamps to create the front and back of the coins.

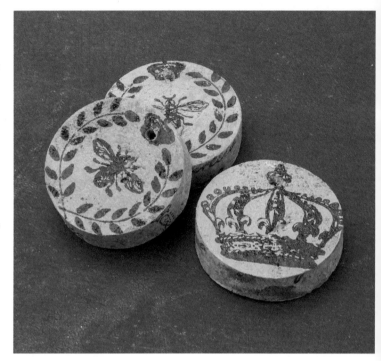

1. Hold onto one end of a cork. Use the hacksaw to slice off rounds of cork slightly thicker than a ¼" (6 mm). (Fig. 1)

2. Sand each side of the cork rounds for a smooth and even surface.

3. Paint a coat of acrylic paint on both sides of the coins, using the darker color first. Repeat with a second coat of the lighter color. (Fig. 2)

4. Press a rubber stamp evenly on the ink pad and then onto the coin. Allow the ink to dry completely before repeating on the other side of the coin with the other stamp. (Fig. 3)

5. Mark where you want to place the hole with a pencil. Use the handheld drill to slowly drill through the coin. Use a small piece of sandpaper to sand the rough edges near the hole. (Fig. 4)

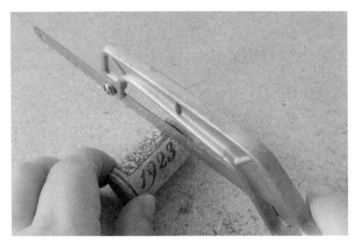

*Fig. 1*

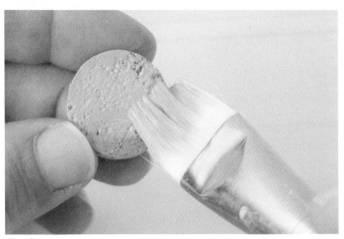

*Fig. 2*

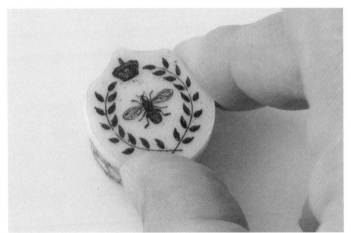

*Fig. 3*

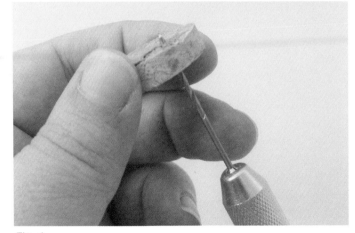

*Fig. 4*

## DESIGNER SPOTLIGHT: ◇ CAT IVINS ◇

**CAT IVINS** of Olive Bites has created an empire upcycling cork into creative pieces of jewelry. She uses images and text in popular themes with clean- and simple-styled jewelry. Cat uses several shapes of corks, both in coins and tubular form, with bright and bold graphics that unify her work. Doing her part to save the environment is important to her business philosophy and artistic pursuits. While her pieces use recycled materials, her work is refined with common elements of metal and the findings she incorporates in her jewelry.

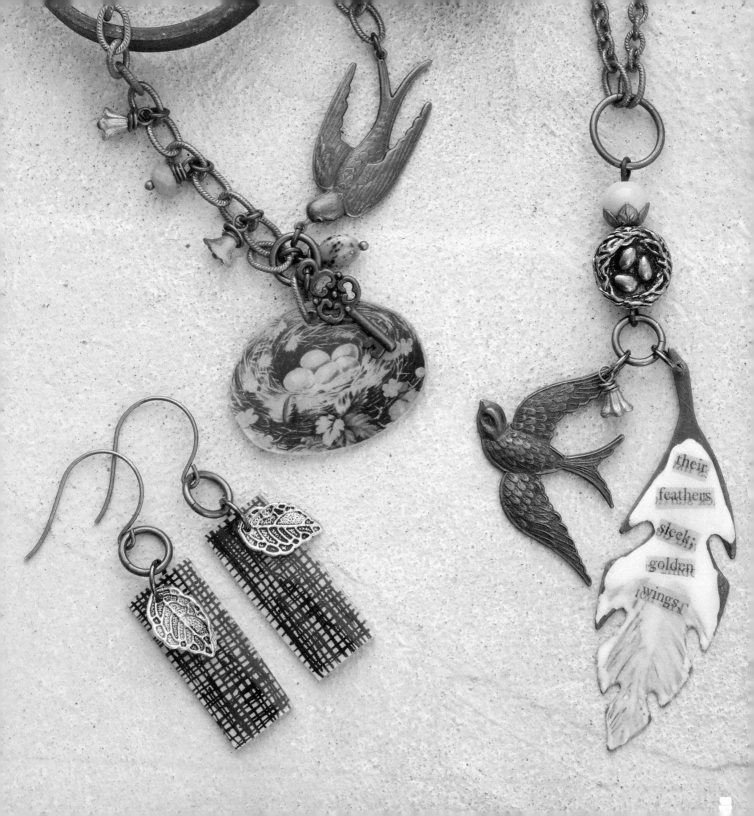

# UNIT 03

# PLASTICS

## PLASTIC BASICS

**Shrink plastic,** which bakes in the oven, allows for a lot of creativity. You can draw your designs, stamp them, or print them. The colors that you use for drawing will darken as the plastic shrinks. Depending on the brand, the plastic shrinks 30 to 50 percent from its original size. Experiment first and adjust the size of your original design as needed.

Bake shrink plastic on a piece of brown paper. I recommend sealing the back of designs that are printed from your home printer after they bake. A light coat of matte sealer will keep the images protected. If a project calls for painting the back of a surface, a sealer isn't needed.

**Resin** is a two-part epoxy that starts out in liquid form. When the two parts mix, they harden and cure. You can add colorant, but only small amounts; larger amounts will add too much moisture. I like to use alcohol inks to color resin. Only one or two drops are needed.

There are several brands of resin. The projects in this book use Ice Resin, which is a jeweler's grade resin. It dries crystal clear, and it's self-doming. The resin will form a dome or rounded shape as it cures. If you use resin with molds, be sure to use mold release spray, which helps items pop easily out of the mold and extends the life of the molds. Let the mold release spray dry completely before adding your resin to the molds. I prefer Mold Release & Conditioner manufactured by Castin' Craft.

# DOODLE CHARMS

## TOOLS AND MATERIALS

→ Jar lid (for template)

→ Permanent black markers

→ Opaque shrink plastic

→ Scissors

→ Large hole punch (¼" [6 mm])

→ Brown paper bag

→ Baking sheet

→ Oven mitt

## TIP

Have a scrap piece of a paper bag on hand when you remove the bakery tray from the oven. If your charm isn't completely flat, quickly flatten it with the brown paper.

**CREATE CHARMS WITH YOUR DOODLES BY USING OPAQUE SHRINK PLASTIC AND A PERMANENT MARKER.** Shrink plastic shrinks drastically, so start with a drawing three times larger than you'd like your finished charm to be. Play with different thicknesses of markers to vary the lines. Keep your doodles simple and geometric, or express yourself with more playful drawings.

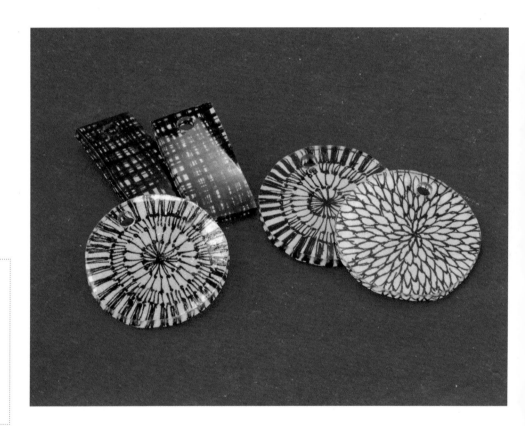

1. Use the jar lid to trace circular shapes with the marker on the plastic before cutting them out with scissors. Cut out the shape from the shrink plastic three times larger than your desired finished size. For a 1" (2.5 cm) charm, the starting size should be 3 (7.5 cm). (Fig. 1)

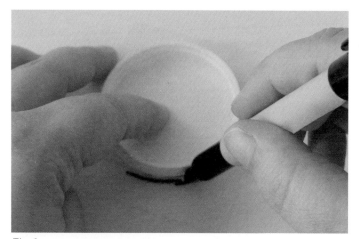

*Fig. 1*

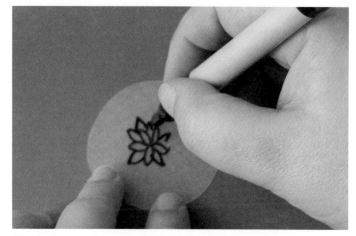

*Fig. 2*

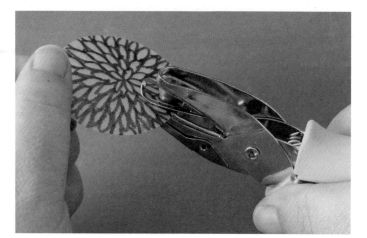

*Fig. 3*

2. On the textured side of the plastic, draw the design with the markers. (Fig. 2)

3. Make a hole at the top of the charm with the hole punch. (Fig. 3)

4. Cut the paper bag to line the baking sheet in a single layer. Place the charms on the paper with the drawing side up. The charms should be placed several inches apart because the plastic bends and folds as it shrinks.

5. Place the pan in a preheated 300°F (150°C) oven for 1 to 3 minutes. The plastic will lie flat when it's done. When it flattens, bake for another 15 seconds and remove it from the oven. Be sure to watch the oven the entire time your pieces are baking. The baking time goes quickly, and overbaked shrink plastic will be cloudy.

◈ **ALTERNATIVE** ◈

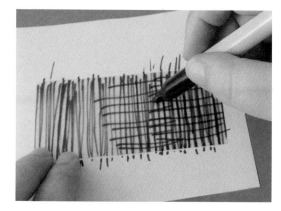

Draw vertical and horizontal lines on a rectangular piece of shrink plastic for modern-looking doodle charms.

# VINTAGE VIGNETTE
## BRACELET CUFFS

## TOOLS AND MATERIALS

- → Computer and printer
- → Opaque shrink plastic
- → Scissors
- → Ruler
- → Pencil
- → Large hole punch (¼" [6 mm])
- → Brown paper bag
- → Baking sheet
- → Oven mitt
- → Paintbrush
- → White acrylic paint
- → Extra-fine steel wool
- → Microcrystalline wax (I used Renaissance wax.)
- → Washcloth or soft rag

## TIP

Create pendants by punching a hole in the top of the design instead of the sides. Rounded shapes will look better if you sand the edges—after they are baked and cooled—using 400-grit sandpaper.

**THESE CUFFS START AS VINTAGE IMAGES PRINTED FROM YOUR HOME COMPUTER.**
There's a vast resource of images to use for your personal projects at graphicsfairy.com. To give the images a vintage feel and to soften the look of the plastic, I used steel wool to crea a matte surface. Remember that the images need to be roughly three times larger than you'd like your finished design to be.

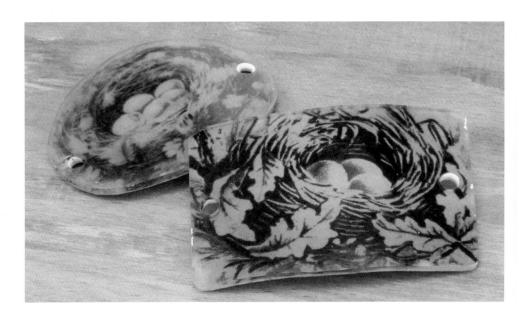

1. Find, download, and resize the images you like; 4"–6" (10–15 cm) images work best for this project. Place the shrink plastic in your printer as you would a piece of paper, making sure the image will print on the textured side of the plastic.

2. Cut out the printed designs with scissors; the ink will smear, so handle with care.

3. Mark the center on both short sides of the cuffs ⅛" (3 mm) from the edge. Make holes at the center marks with the hole punch. (Fig. 1)

4. Cut the paper bag to line the baking sheet in a single layer. Place the cuffs on top of the paper with the drawn side up. The pieces should be placed several inches apart because the plastic bends and folds as it shrinks.

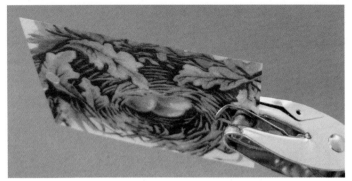

*Fig. 1*

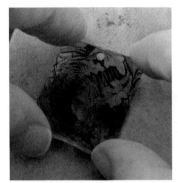

*Fig. 2*

*Fig. 3*

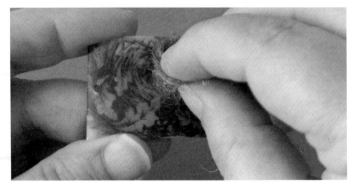

*Fig. 4*

5. Place the pan in a preheated 300°F (150°C) oven for 1 to 3 minutes. The plastic will lie flat when it's done. When it flattens, bake for another 15 seconds and remove it from the oven. Be sure to watch the oven the entire time your pieces are baking. The baking time goes quickly, and overbaked shrink plastic will be cloudy.

6. It's best to shape the cuff as it's cooling: pinch the edges with the holes toward each other to form a slight curve. Be careful; it will be warm. Let it cool completely. (Fig. 2)

7. Paint the back of the cuff with white acrylic paint. One coat is all that is needed. The color will bleed through as it dries. (Fig. 3)

8. With a small piece of steel wool, rub in a circular motion over the top of the cuff, working evenly to create a matte finish on the surface. (Fig. 4)

9. Rub a thin layer of wax over the surface. Buff it with a washcloth or soft rag.

## TIP

Save your unprinted scraps for Lab 24: Doodle Charms.

## DESIGNER SPOTLIGHT:
### ◇ YVONNE IRVIN-FAUS ◇

**YVONNE IRVIN-FAUS is** an exuberant painter even though her canvases are minute! Yvonne draws and paints on shrink plastic to create her line of jewelry components sold through her business called My Elements by Yvonne. She stays true to her playful spirit by using bold lines and bright colors. When creating your own jewelry, think about what color story you want to tell. Use your personal color palette to create a series of beads that are uniquely you.

# BUTTERFLY CHARMS

## TOOLS AND MATERIALS

→ 3″ (7.6 cm) rubber stamp

→ Permanent ink pad (I used StazOn Ink.)

→ Opaque shrink plastic

→ Permanent markers

→ Scissors

→ Large hole punch (¹/₄″ [6 mm])

→ Brown paper bag

→ Baking sheet

→ Oven mitt

**THESE BUTTERFLY CHARMS ARE CREATED WITH A RUBBER STAMP AND COLORED WITH PERMANENT MARKERS.** Use them individually for earrings, or punch a hole in each wing and attach three or more together for a delicate necklace on a chain.

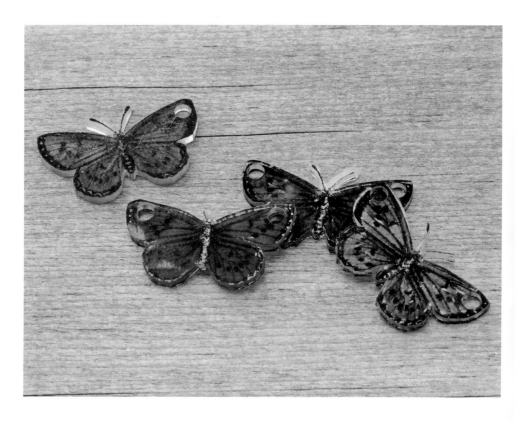

1. Press the rubber stamp firmly and evenly on the ink pad and stamp the design onto the textured side of the shrink plastic. Allow the ink to dry.

2. Color the stamped design with the markers, working from the center and coloring toward the edges. Remember that the color will darken considerably when the plastic is baked. (Fig. 1)

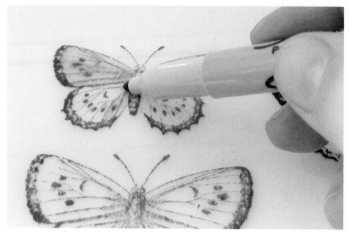

Fig. 1

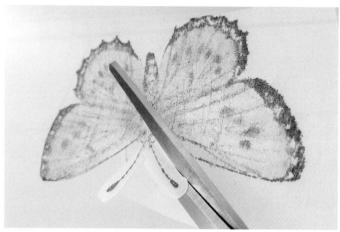

Fig. 2

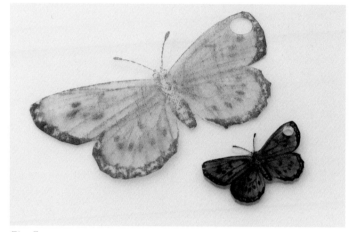

Fig. 3

3. Cut out the stamped design with the scissors. Leave a large border around the antennae to prevent the small pieces from becoming too fragile. (Fig. 2)

4. Use the hole punch to make a hole at the top of one wing if you're making earrings; for a necklace or bracelet, make holes in both wings.

5. Cut the paper bag to line the baking sheet in a single layer. Place the cutout butterflies on the paper with the stamped side facing up. The pieces should be placed several inches apart because the plastic bends and folds as it shrinks.

6. Bake the charms in a preheated 300°F (150°C) oven for 1 to 3 minutes. The charms will curl and then flatten while they bake. When they flatten, they are done. Remove the baking sheet from the oven immediately and allow the charms to cool before removing them. (Fig. 3)

# LAB 27 PHOTO CHARMS

## TOOLS AND MATERIALS

→ Photos

→ Computer and printer

→ Opaque shrink plastic

→ Scissors

→ Large hole punch (¼" [6 mm])

→ Brown paper bag

→ Baking sheet

→ Oven mitt

→ Paintbrush

→ Matte sealer
   (I used Mod Podge.)

### TIP

Use free online photo-collage software to create a charm-collage of your vacation images.

**TURN YOUR VACATION SNAPSHOTS INTO SMALL CHARMS FOR JEWELRY THAT HOLDS A SPECIAL MEMORY.** As the plastic shrinks, the images will get darker, so pick bright images with good contrast.

1. Resize your images with online photo-editing software so that they measure 3"–6" (7.5–15 cm) wide. A 3" (7.5 cm) image will create a 1" (2.5 cm) charm. Place the shrink plastic in your printer as you would a piece of paper, making sure the image will print on the textured side of the plastic. Print the images.

2. Cut out the design with scissors; the ink will smear so handle with care. (Fig. 1)

Fig. 1

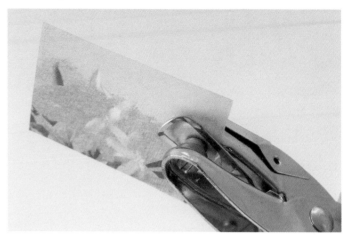
Fig. 2

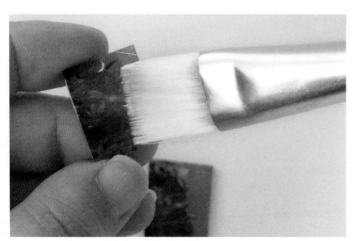
Fig. 3

3. Punch a hole at the top of each image. (Fig. 2)

4. Cut the paper bag to line the baking sheet in a single layer. Lay the cutout images on top of the paper with the printed side up. The images should be placed several inches apart because the plastic bends and folds as it shrinks.

5. Place the pan in a preheated 300°F (150°C) oven for 1 to 3 minutes. The charms will curl and then flatten while they bake. When they flatten, allow them to bake for another 15 seconds. Remove the baking sheet from the oven and allow the charms to cool. Be sure to watch the oven carefully during baking. The baking process goes by very quickly, and overbaked pieces will be cloudy.

6. After the charms have cooled completely, paint a thin coat of matte sealer on the image. (Fig. 3)

# GEO WATERCOLOR
## MATCHSTICKS

## TOOLS AND MATERIALS

→ Opaque shrink plastic

→ Thin latex gloves or pumice soap and scrubbing sponge

→ 2 colors of alcohol inks (I used yellow and dark teal.)

→ Paintbrush

→ Paper toweling

→ Permanent oil-based marker (I used a gold Sharpie.)

→ Ruler

→ Pencil

→ Scissors

→ Large hole punch (¼" [6 mm])

→ Brown paper bag

→ Baking sheet

→ Oven mitt

## TIP

Alcohol ink is very difficult to remove from your fingers. Wear thin latex gloves or use pumice soap and a scrubbing sponge to remove the ink from your fingers immediately.

**INSPIRED BY THE GOLD LINE WORK IN GUSTAV KLIMT'S PAINTINGS, I USED ALCOHOL INKS AND AN OIL-BASED PERMANENT GOLD MARKER TO CREATE THESE GEOMETRIC DESIGNS.** After they were painted and decorated, I cut them into long strips to create skinny matchstick charms. They work beautifully as earrings.

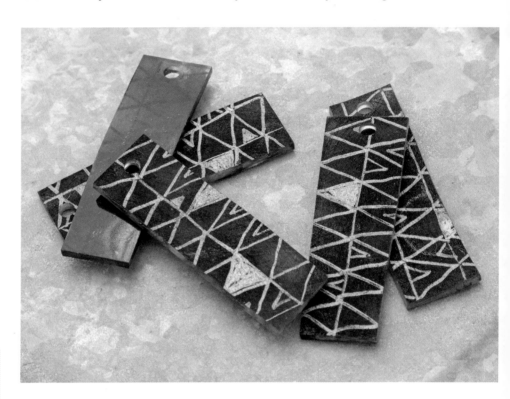

1. Lay a 7" x 7" (18 x 18 cm) sheet of shrink plastic on your work surface, textured side up. Place several drops of dark teal alcohol ink on the shrink plastic. Use a brush to spread the ink over the plastic. (Fig. 1)

2. Place several drops of yellow ink evenly across the surface. The drops will create a ring or ripple effect. Blot the surface lightly with a paper towel to remove any excess ink. Repeat, adding more dark teal drops on top of the yellow ones. Set aside to dry. (Fig. 2)

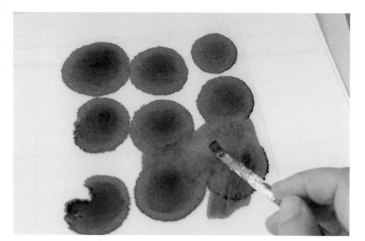

*Fig. 1*

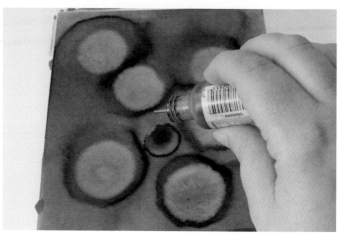

*Fig. 2*

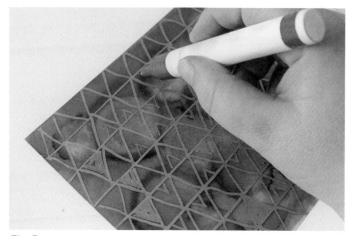

*Fig. 3*

3. When the ink has dried completely, use the marker to draw on the plastic sheet. For this project, I drew straight lines, then triangles. I filled in a few of the triangles with patterns. (Fig. 3)

4. Use a ruler and pencil to draw 1" x 3 ½" (2.5 x 8.9 cm) rectangles on the plastic sheet. Cut out the rectangles with scissors. Punch a hole at the top of each rectangle.

5. Cut the paper bag to line the baking sheet in a single layer. Lay the rectangles on top of the paper with the painted side up. Place the pieces several inches apart because the plastic bends and folds as it shrinks.

6. Place the pan in a preheated 300°F (150°C) oven for 1 to 3 minutes. The charms will curl and then flatten while they bake. When they flatten, allow them to bake for another 15 seconds. Remove the baking sheet from the oven and allow the charms to cool. Be sure to watch the oven carefully during baking. The baking process goes by very quickly, and overbaked pieces will be cloudy.

## TIP

Punch a hole at the top and bottom of each rectangle before baking if you want to design an earring with a dangle at the bottom. Small glass beads or tiny brass stars make great additions to this painterly project.

## TOOLS AND MATERIALS

→ Two-part molding putty

→ Waxed paper

→ Sea urchin shells or seashells

→ Mold-release spray

→ Two-part epoxy resin

→ Alcohol ink (I used Ranger Adirondack Alcohol Inks.)

→ Measuring cup

→ Mixing sticks or stirrers

→ Shallow plastic container (and lid) with a 1/4" (6 mm) -thick layer of uncooked rice

→ Scissors

→ Scrap wood block

→ Rotary tool with 2 mm drill bit

## TIP

Exhaling a hot breath onto the resin after it has set will release quite a few of the bubbles. Another trick is to wave an embossing gun quickly over the molds. The heat releases any air bubbles.

**THESE BEADS MIMIC BEACH GLASS IN SHAPES INSPIRED BY THE SEA.** You get the transparent color by adding alcohol inks to resin. Pair these pendants with ocean-inspired charms and recycled glass in beach-glass colors that are perfect for seafaring designs.

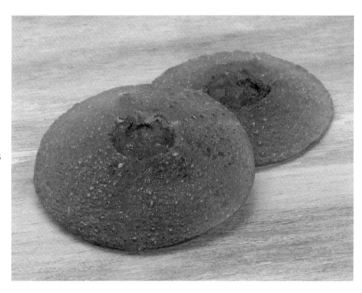

1. Pinch off equal parts of each of the two molding putty materials. Squeeze and fold the materials together to blend them completely. Roll them into a ball and place on waxed paper.

2. Press the sea urchin into the putty, creating a deep impression. Leave the sea urchin in the compound until it firms up, usually within 10 to 15 minutes. (Fig. 1)

3. Pop the urchin out of the mold and spray the impression with mold-release spray. Create several different molds for this project.

4. Mix equal parts of the two resin materials together in a mixing cup. Mix at least 1/2 cup (118 ml) of resin for each batch that you create. Stir the two parts together slowly with the mixing sticks for about a minute, being careful not to make air bubbles.

5. Mix in one or two drops of alcohol ink and continue stirring until completely mixed. (Fig. 2)

6. Set the molds in the shallow container, using the rice to stabilize them. Make sure all the molds have been sprayed with mold release spray.

7. Pour the resin slowly into the molds. Do not overfill. (Fig. 3)

Fig. 1

Fig. 2

Fig. 3

Fig. 4

8. Resin likes dry, warm air; it will dry more quickly under those conditions. That said, your resin will need about 12 hours to set. Place the plastic lid over the molds (but do not seal the container) and walk away—don't touch them! After 12 hours, the resin will be cured enough to remove your beads from the molds. Pop them out. I like to use scissors and cut off uneven edges. Set the beads in a dry area to cure for another 12 hours before drilling. (Fig. 4)

9. Place a molded resin bead on a piece of scrap wood. Use the rotary tool to drill a hole at the top.

*Note: Wait until the resin is completely cured, usually 72 hours after it was poured, before storing your molded beads in airtight containers.*

# ALTERNATIVE

You can make a mold from just about anything for this project, let your imagination go wild! This alternative uses the button mold from the Rosy Posy project (Lab 9).

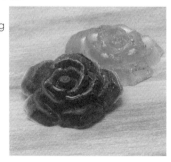

# DAZZLED DRUZY
## CHARMS

## TOOLS AND MATERIALS

→ Glass glitter
(I used metallic colors.)

→ Metal bezels

→ Shallow plastic container (with
lid) filled with a 1/4" (6 mm)
-thick layer of uncooked rice

→ Two-part epoxy resin
(I used Ice Resin.)

→ Measuring cup

→ Mixing sticks or stirrers

**IN JEWELRY MAKING, DRUZY IS THE SPECIAL EFFECT CREATED WHEN TINY CRYSTALS GROW OVER COLORFUL MINERALS.** The dazzling crystals are drilled into beads or fashioned into pendants. Glass glitter and resin make these bezel charms sparkle and shine. Bezels can be found wherever jewelry-making supplies are sold. Use different sizes as you create your own druzy-inspired pieces.

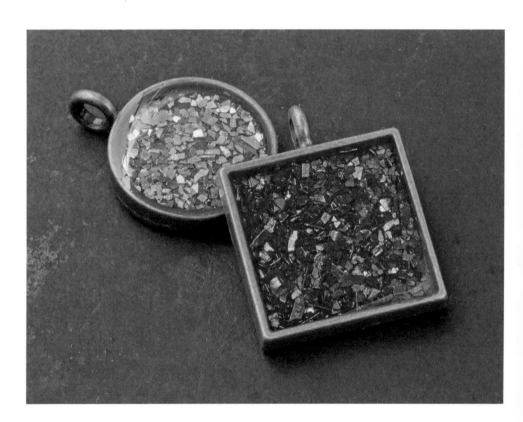

1. Sprinkle a layer of glitter into the bezels. Place the bezels in the shallow container filled with rice. (Fig. 1)

2. Mix equal parts of the two-part resin together in the mixing cup. Mix at least 1/2 cup (118 ml) of resin for each batch that you create. Stir the two parts together slowly with the mixing sticks for about a minute. Be careful not to create air bubbles as your stir.

*Fig. 1*

3. Pour a small amount of resin into each bezel or use the stirrer to drip in the resin. Be careful not to overfill the bezels. Exhale a hot breath over the bezels to release any air bubbles. (Fig. 2)

4. Cover the bezels loosely with the plastic lid but do not seal. Allow the resin to cure for 24 hours. Do *not touch* until the 24 hours have passed, or you will leave fingerprints on the resin.

*Fig. 2*

## TOOLS AND MATERIALS

→ Patina paint
   (I used Vintaj Patina paint.)

→ Old plastic lid

→ Metal blank
   (I used a feather from Vintaj.)

→ Paintbrush

→ Scissors

→ Book pages

→ Quick-dry tacky glue

→ Matte sealer
   (I used Mod Podge.)

→ Two-part epoxy resin

→ Measuring cup

→ Stirrer

→ Shallow plastic container
   (with lid) filled with a ¼"
   (6 mm) -thick layer of rice

**CREATE A FAUX-ENAMEL PENDANT WITH A POETIC SAYING CLIPPED FROM OLD BOOKS.** This one begins with a metal blank. Use a feather-shaped blank as in this project or spread your wings and find a shape that speaks to you. You'll find many shapes available where jewelry supplies are sold.

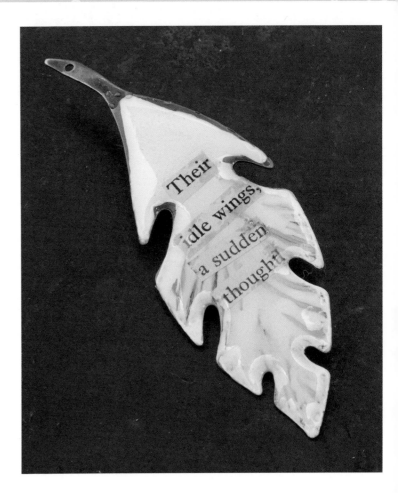

1. Shake the patina paint. Put a few drops on the plastic lid. Starting at the top of the metal blank, brush on a coat of paint, avoiding the edges of the blank. As you near the bottom, feather the paint with the brush, letting the brush strokes show. Allow the paint to dry completely. (Fig. 1)

2. Use scissors to cut the desired words or phrases from the book page. Glue the word cutouts to the painted surface of the blank. Seal the surface of the paper with a matte sealer. (If you skip this step, the words from the back of the page will bleed through.) Allow the sealer to dry. (Fig. 2)

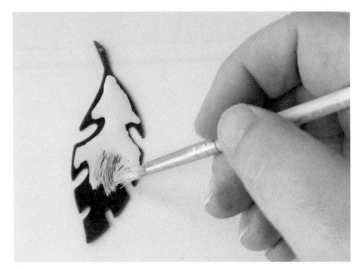

Fig. 1

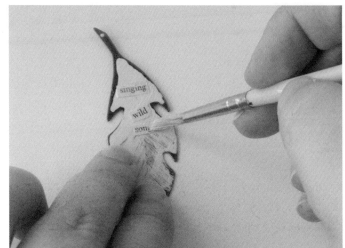

Fig. 2

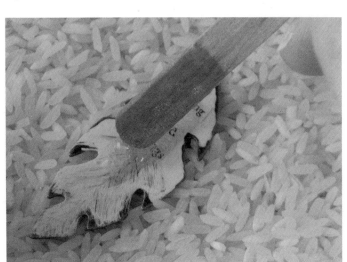

Fig. 3

3. Mix equal parts of the resin together in the measuring cup. Stir slowly for about 1 minute, avoiding air bubbles.

4. Place the blank flat in the shallow plastic container. The rice will keep it stable.

5. Use the stirrer to drop a thin layer of resin onto the center of the blank. Spread the resin evenly over the painted surface with the wooden stirrer avoiding the edges of the pendant. (Fig. 3)

6. Let the resin cure for 12 to 24 hours. *Do not touch* it while the resin is curing. Place the lid over the container to prevent dust from settling on the resin while it cures. Do not close the lid tightly; place it slightly askew on top of the container.

# GLOSSY FLORAL
## PENDANTS

## TOOLS AND MATERIALS

→ Vintage images

→ Computer and printer

→ Opaque shrink plastic

→ Scissors

→ Large hole punch (¼" [6 mm])

→ Brown paper bag

→ Baking sheet

→ Oven mitt

→ Paintbrush

→ White acrylic paint

→ Two-part epoxy resin

→ Measuring cup

→ Mixing stick or stirrer

→ Shallow plastic container
(with lid) filled with ¼" (6 mm)
-thick layer of uncooked rice

## TIP

Save your unprinted shrink-plastic scraps for Lab 24: Doodle Charms.

**COVERING A VINTAGE VIGNETTE PENDANT WITH RESIN IS ONE TECHNIQUE FOR CREATING A CLASSIC LOOK.** The resin acts as a magnifying glass, creating a bold finish for the design. The resin is self-doming and will swell up in the center of the pendant, creating an even finish on the surface with slightly beveled edges.

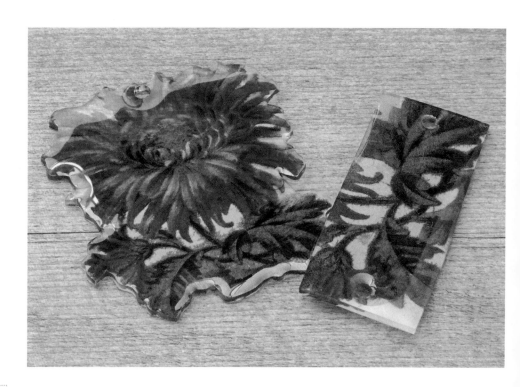

1. Find vintage images online and size them accordingly; 4" to 6" (10.2 to 15.2 cm) images work best for this project. Place opaque shrink plastic sheets in your printer as you would a normal piece of paper. Make sure the images will print on the textured side of the plastic. Print the images.

2. Cut out the image with scissors. The ink will smear so handle with care.

Fig. 1

Fig. 2

Fig. 3

3. Punch a hole at the top of each image. (Fig. 1)

4. Cut the paper bag to line the baking sheet in a single layer. Layer the cutout pieces on the paper with the printed side up. Make sure they are placed several inches apart because the plastic bends and folds as it shrinks.

5. Place the pan in a preheated 300°F (150°C) oven for 1 to 3 minutes. The charms will curl and then flatten while they bake. When they flatten, allow them to bake for another 15 seconds. Remove the baking sheet from the oven and allow the charms to cool. Be sure to watch the oven carefully during baking. The baking process is very quick, and over baked pieces will be cloudy.

6. Paint the back of the pendant with white acrylic paint. One coat is all that is needed. The color will bleed through while it dries. (Fig. 2)

7. Mix equal parts of the resin together in the measuring cup. Stir slowly for about 1 minute, avoiding air bubbles.

8. Place the pendant flat on the rice in the container. Drop a thin layer of resin onto the center of the pendant and spread the resin evenly over the surface with the wooden stirrer. Avoid the hole in the pendant. (Fig. 3)

9. Let the resin cure for 12 to 24 hours. Do not touch while the resin is curing. You may loosely place the container lid over the pendant to prevent dust from settling on it while it cures. Do not close it tightly.

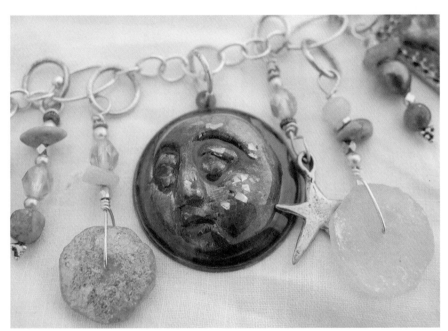

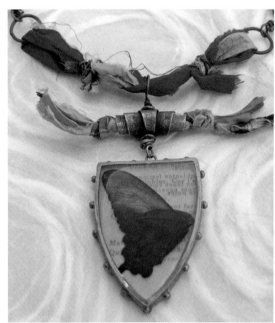

JEN CUSHMAN IS AN INNOVATIVE JEWELRY MAKER WHO HAS SPENT MANY YEARS AS ONE OF THE CREATIVE PARTNERS BEHIND ICE RESIN. JEN TEACHES HER UNIQUE CLASSES ACROSS THE COUNTRY, COMBINING MIXED MEDIA WITH WIRE, METAL, RESIN, AND CLAY. HER ECLECTIC DESIGNS ARE AN EXPLORATION OF MANY INSPIRATIONS AND A RESULT OF FEARLESS PLAYING WITH MATERIALS.

**Q:** Jen, you had a late start in your art career. How did you become involved in making jewelry?

**A:** I always tell people that words are my talent and art is my passion. I was born creative and am a lifelong crafter. When I was in high school, I had wonderful English teacher who told me I was a fantastic writer and suggested I sign up for my school newspaper. Journalism came naturally to me, so I decided that's what I was going to do with my life, with crafty stuff on the side. I found mixed media (then called altered art) in 1999 when my son was born. That's what led me down the path I'm on today. I'm a jewelry maker, but I still consider myself a mixed-media artist.

While I had dabbled in jewelry making back in high school, it didn't become a focus of mine until after I took a workshop with Susan Lenart Kazmer in 2006. Her innovative techniques and signature style blew me away. I wrote about her. We became friends and, eventually, business partners.

**Q:** Words and images are a reoccurring theme in your jewelry. Where do you collect your inspirations?

**A:** Words are just as powerful to me as images. In my work, there's not one without the other. It comes from my writing background. Like most artists, I see images in my mind's eye. I can see the shapes, colors, lines, and I know which materials and techniques I want to use. But I also see words. The words and images form a storyline, and I work on them concurrently. My inspiration comes from life. I'm constantly taking pictures, and the pictures stay in my mind. Somewhere in there is a word, a line of poetry, or a phrase that also caught my attention and colors that speak to me. And when I'm in my studio, all these random things come together as a design and storyline and are released.

**Q:** Do you sit down with an idea in mind or do your materials speak to you as you create?

**A:** Sometimes I sketch and get the idea down in my art journal. But most of the time the ideas are tucked away but close enough in my brain that I can access them when I'm in the studio. One compulsively organized friend calls it keeping everything on the back of my eyelids. Some of my favorite pieces of jewelry, however, come about when I'm in a frenzy of creation (usually for a big deadline) and find all kinds of flotsam and jetsam in my studio. I'll sit right down and make a crazy mixed-media necklace. These are the times that the story comes as I build my work, rather than beforehand.

**Q:** What are your top three tips for working with resin?

**A:** (1) Make sure your studio is nice and warm when you pour. Resin likes an ambient temperature of 72°F (22°C) or warmer. I live in Arizona, so there are times when my studio gets into the nineties and the resin "thins out," which means I have to work a little harder to get the dome that happens naturally in cooler weather. For artists who have the opposite problem with cold weather, resin pours will go easier if you warm the resin bottles in bowls of hot water.

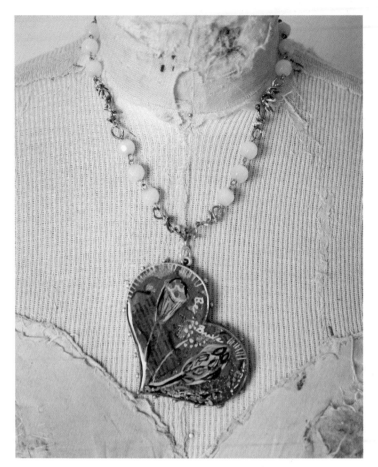

(2) Remember that when you embed charms into resin bezels, you're introducing air into the already-poured resin. Trapped air bubbles will work their way to the surface as the resin cures. If you don't pop the bubbles when the resin is in a liquid state, you will need to use a rotary tool or flexible shaft to drill out the bubbles after the resin is dry. You can then mix up more resin and add another layer. Use a toothpick or piece of wire to work the liquid resin into the drilled hole.

(3) It's almost impossible to mess up resin as long as you measure out equal parts of the two compounds and you mix the two parts together thoroughly. If your bezel is still tacky to the touch after twenty-four hours, you can mix up another batch of resin and add another layer to your piece. It works perfectly every time as long as you use an equal one-to-one ratio and mix thoroughly.

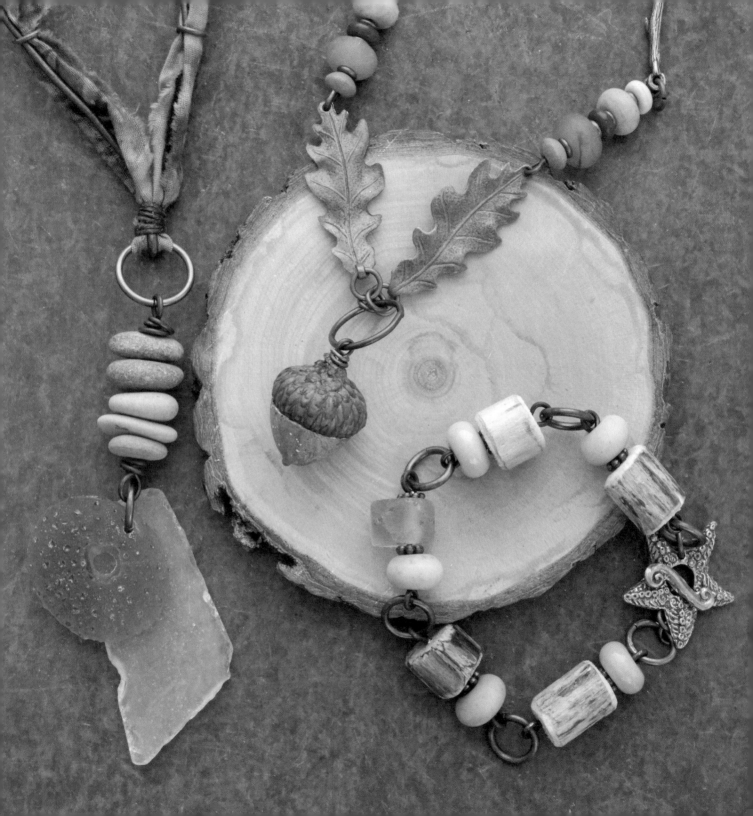

# UNIT 04

# BACKYARD

## NATURAL BASICS

There is something very satisfying about transforming found treasures into jewelry that holds a memory of a vacation or favorite space. Whether a day at the beach or a beautiful walk in the woods is your inspiration, you can create one-of-a-kind beads from natural mementos.

### Beach Glass and Pebbles

When drilling glass and stone, wear safety glasses and use a diamond drill bit. I like to use a 2 mm drill bit for a smaller hole. Keep the material you are drilling wet to extend the life of the drill bit and to keep the material cool while the drill bores through. There's no need to submerge items in water; a spray bottle works fine.

Keep the dust that forms when drilling glass and stones wet, so that it doesn't get in the air. Wipe up the sludge immediately so that it doesn't dry and become airborne. I keep baby wipes on hand for just that purpose.

### Trees and Wood

Allow twigs and branches to dry completely for several days before working with them. Wood will need to be sealed to protect it and to create a smooth finish for easy wear. Sand wooden beads thoroughly before sealing them.

Projects that use soft balsa wood must be sealed to create a hard surface. Until they are sealed, even a fingernail can dent them.

# DRILLED BEACH GLASS

## TOOLS AND MATERIALS

→ Found beach glass

→ Scrap wood block

→ Spray bottle with water

→ Safety glasses

→ 2 mm diamond drill bit

→ Rotary tool
(Battery operated is preferred.)

→ Baby wipes

**DRILLING GLASS ISN'T DIFFICULT; IT JUST TAKES PATIENCE, PRACTICE, AND A FEW SIMPLE TOOLS.** It's easier to drill flat pieces of glass. Look for glass that has been completely smoothed by the elements. I recommend larger pieces for this project.

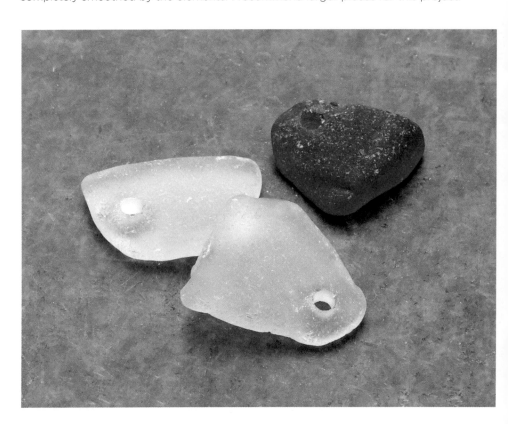

1. Lay the beach glass on top of the scrap wood block. Spray the glass with water.

2. Put on the safety glasses. Hold the piece of glass firmly in place at one end of the wood block. With the rotary drill in hand, aimed at a slight angle away from you, start the hole by drilling a shallow mark in the glass. (Fig. 1)

3. Spray the glass with water. Now hold the drill directly above the mark you made in step 2. Turn on the drill and begin drilling straight down into the glass.

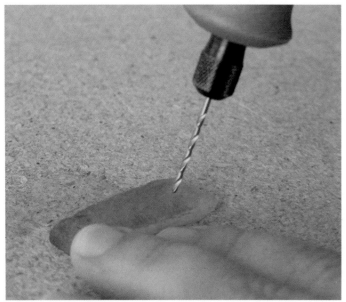

*Fig. 1*

4. Lift the drill. Spritz the glass with water again. Continue drilling. Repeat this process, working slowly, drilling the hole in increments until the drill bit has gone through the glass. Don't push too hard or the glass may crack. Keep the glass wet at all times. (Fig. 2)

5. Turn the piece of glass over. Spray it with water. Drill through the hole from back to front to smooth the edges.

6. Spritz the glass with water and clean it with a baby wipe. Clean the glass dust and small shards off the wood block with a baby wipe and discard carefully.

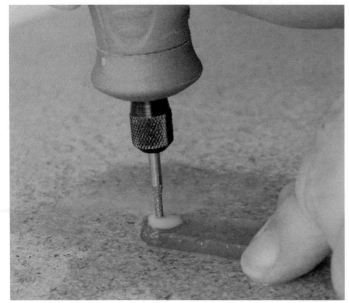

*Fig. 2*

## DESIGNER SPOTLIGHT:
## ◇ STACI LOUISE SMITH ◇

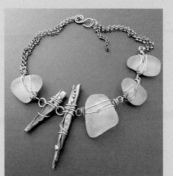

Award-winning bead maker **STACI LOUISE SMITH** takes a fresh mixed-media approach to her jewelry. She combines beach glass, stones, polymer, and metal clay elements in her wild creations. What keeps her jewelry style looking cohesive? She is a whiz at wire wrapping and using wire to literally tie her distinct collections of elements together. Staci works with beach glass and stones by drilling them and capturing them in wire for her rustic and earthy jewelry.

# GILDED PEBBLES

## TOOLS AND MATERIALS

→ Drilled beach pebbles (See Note below.)

→ Oil-based permanent gold marker (I used a Sharpie.)

→ Embossing gun

→ Scrap wood block

*Note: Beach pebbles are drilled in exactly the same manner as beach glass. Follow steps 1 through 6 for drilling glass in Lab 33.*

**I GAVE THESE BEACH PEBBLES A GILDED TREATMENT WITH OIL-BASED PERMANENT MARKER.** The effect is fun and trendy. When collecting pebbles for drilling, look for smooth, flat examples in gray, cream, or brown, which are sedimentary rocks and much easier to drill than rough igneous stones or quartz.

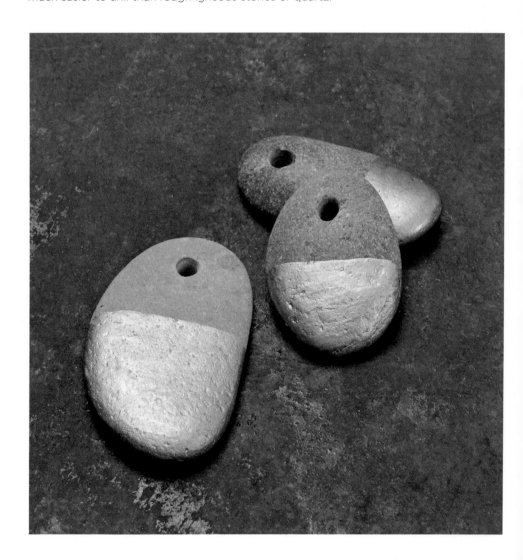

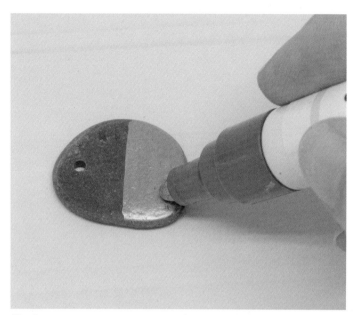

*Fig. 1*

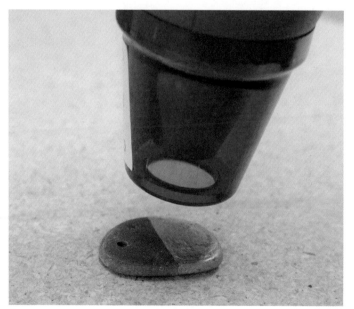

*Fig. 2*

1. Place a drilled pebble on your work surface. With the gold marker, draw a line about one-third of the way up from the bottom of the pebble.

2. Draw even, horizontal lines of gold around the pebble to cover the bottom third. Fill in any gaps in the color. (Fig. 1)

3. Let the gold ink dry. Place the pebble on the wood block. Heat it evenly with the embossing gun for 20 to 30 seconds. Let the pebble cool. Turn it over and repeat. (Fig. 2)

## ALTERNATIVE

Carefully drill smaller stones in the center to create beads.

# MESSAGE FROM THE
# SEA CHARMS

## TOOLS AND MATERIALS

→ Polymer clay
(I used Premo in white.)

→ Seashell

→ Paintbrush

→ Liquid translucent polymer clay

→ 8 mm jump ring

→ Acrylic roller

→ Small rubber alphabet stamps

→ Baking sheet

→ Alcohol ink
(I used Stream Adirondack
Alcohol Ink by Ranger.)

→ Thin latex gloves or pumice
soap and scrubbing sponge

→ Plastic lid

→ Baby wipes

## TIP

Alcohol ink is very difficult to
remove from your fingers. Wear
thin latex gloves or use pumice
soap and a scrubbing sponge to
remove the ink from your fingers
immediately.

**WITH POLYMER CLAY, WIRE, AND RUBBER STAMPS, YOU CAN TRANSFORM A SEASHELL INTO A TINY TREASURE.** This project uses a jump ring to turn a seashell into a charm. An alternative is to use pearl-effect polymer clay for a shimmering design.

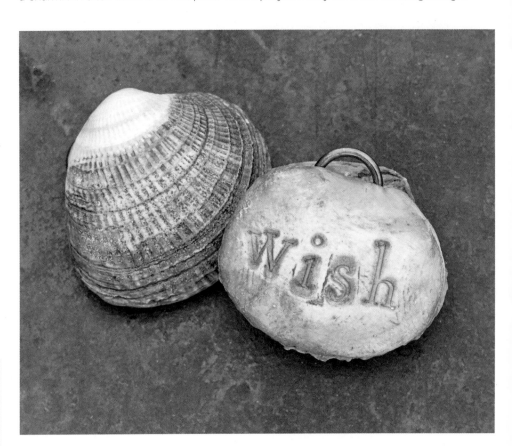

1. Roll a small piece of clay in your palms to form a ball. You will want a piece that will fit inside your shell but not spread over the sides. Brush the inside of the shell with liquid translucent clay to work as a glue and press in the small ball of clay, flattening it into the shell. (Fig. 1)

Fig. 1

Fig. 2

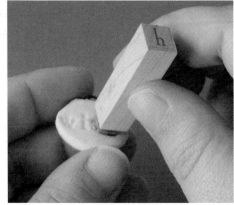

Fig. 3

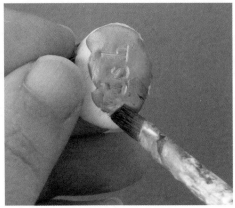

Fig. 4

Fig. 5

2. Make sure the jump ring is closed and embed the jump ring two-thirds of the way into the clay at the top of the shell. The ring should be flat at the edge of the shell with only a small loop sticking out above the shell. Place a small piece of flattened clay on top of the embedded part of the ring. Smooth out the edges with your finger. (Fig. 2)

3. Roll the surface of the clay with the acrylic roller to flatten it.

4. Use the rubber stamps to press a word into the clay. (Fig. 3)

5. Put the pendant on a baking sheet. Bake the clay according the manufacturer's directions. Allow it to cool completely.

6. Put a few drops of alcohol ink on the plastic lid. Paint over the surface of the clay. Wipe the excess ink from the surface with a baby wipe, allowing the ink to remain in the pressed letters. Allow the ink to dry. (Fig. 4)

7. Turn the pendant shell side up. Put a few more drops of alcohol ink on the plastic lid. Starting at the bottom of the shell, brush on a light coat of ink. Brush toward the top of the shell. Create an ombré effect by repeating with another coat of ink on the lower two-thirds of the original painted area. Allow the ink to dry. Repeat with a third coat on the bottom one-third of the shell. (Fig. 5)

*Note: Avoid drilling seashells for bead making. It can be hazardous to breathe the dust.*

# DRIFTWOOD BEADS

## TOOLS AND MATERIALS

→ Driftwood sticks

→ Small hacksaw

→ Safety glasses

→ Scrap wood block

→ Rotary tool with 2-mm drill bit and sanding barrel

→ 18-gauge wire

→ Paintbrush

→ Wood polyurethane sealer (I used Minwax Polycrylic in satin.)

→ Bead rack

*Note: When collecting driftwood, make sure it can't be snapped in half easily. Let pieces dry for several days before using them.*

**CUT INTERESTING PIECES OF DRIFTWOOD INTO SMALL PIECES TO CREATE RUSTIC, EARTHY BEADS.** Use them in your beach- or woodland-themed jewelry.

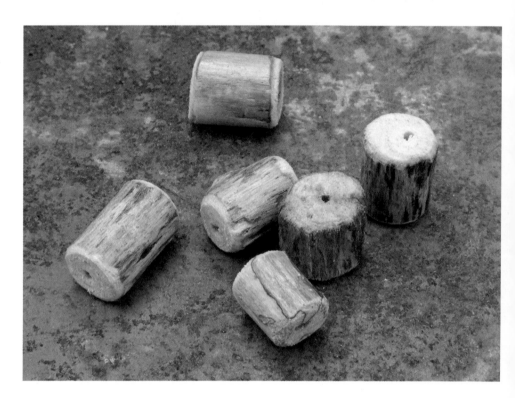

1. Hold one end of a piece of driftwood firmly. Use the hacksaw in long, sawing motions to cut off pieces that are ½" to ¾" (1.3–2 cm) long. (Fig. 1)

2. Put on the safety glasses. Place a driftwood bead on the wood block. Hold the piece firmly at its outer edges. With the rotary tool and drill bit, drill slowly lengthwise through the center of the bead. (Fig. 2)

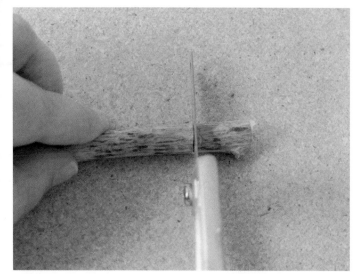

*Fig. 1*

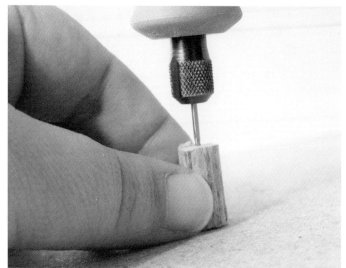

*Fig. 2*

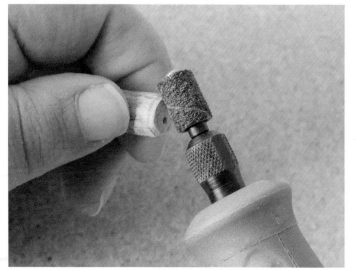

*Fig. 3*

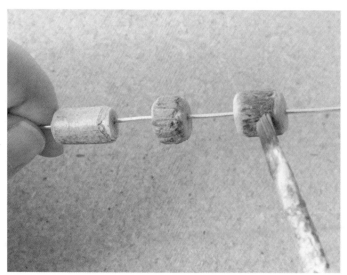

*Fig. 4*

3. Switch to the sanding barrel on the rotary tool. Sand the end of each bead, holding it firmly as your run the sanding barrel over the edges and across the top and bottom. (Fig. 3)

4. Thread the beads on the wire and paint a coat of wood polyurethane sealer entirely around each bead. Lay the wire on the bead rack to dry. (Fig. 4)

# WOOD GEMS

## TOOLS AND MATERIALS

→ Balsa wood: ¼″ and ½″ (6 mm and 1.3 cm) blocks

→ Craft knife

→ Small handheld drill (also known as a pin vise)

→ 400-grit sandpaper

→ Toothpicks

→ Paintbrush

→ Acrylic paint (I used Martha Stewart Crafts Multi-Surface Satin paint.)

→ Foam block

→ Matte sealer (I used Mod Podge.)

**BALSA WOOD IS LIGHTWEIGHT AND CAN EASILY BE CUT AND SHAPED WITH A CRAFT KNIFE, MAKING IT PERFECT FOR A BEGINNER'S WOOD-CARVING PROJECT.** These beads are shaped by slicing thin facets off a small block of balsa. Practice carving on a spare piece of balsa wood. It's easier than you think.

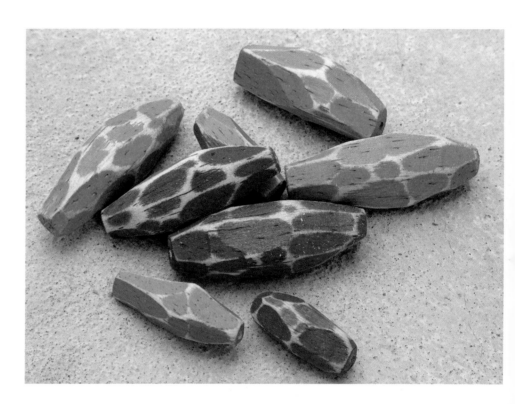

1. For large beads, use the ½″ (1.3 cm) -thick balsa. With the craft knife cut off a 1½″ (3.8 cm) length of wood. For small beads, use the ¼″ (6 mm) wood block cut into 1″ (2.5 cm) lengths.

2. Hold the piece of wood vertically on your work surface. Use the craft knife to carve shallow facets from the wood, working away from your body. Working from the center of the bead toward the ends, change the angle of the craft knife to shape the wood.

Fig. 1

Fig. 2

Fig. 3

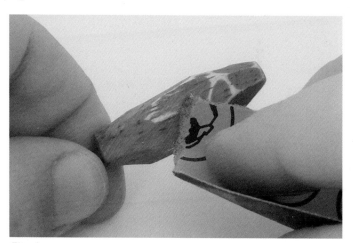
Fig. 4

3. Repeat on each side of the bead.

4. Taper the ends of the bead, cutting smaller facets at the top and bottom. (Fig. 1)

5. Drill a hole through the bead vertically with the hand held drill. If the bead is longer than the drill bit, drill one side, turn the bead over, and drill the other side to meet in the middle. Thread a wire through the bead to make sure the hole goes all the way through. (Fig. 2)

6. Sand the bead.

7. Place the bead on the end of a toothpick. Apply an even coat of paint over the entire surface. Poke the toothpick into the foam block to hold the bead while it dries. (Fig. 3)

8. Sand the edges of the bead's facets to reveal the wood. (Fig. 4)

9. Place the bead back on the toothpick. Brush an even coat of matte sealer over the entire bead. Allow it to dry and repeat with a second coat.

# BUOY BEADS

## TOOLS AND MATERIALS

→ Balsa wood: ³/₈" (1 cm) and ½" (1.3 cm) blocks

→ Craft knife

→ 400-grit sandpaper

→ Pin-vise drill

→ 4" (10.2 cm) piece of 18-gauge wire

→ Washi tape

→ Toothpicks

→ Paintbrushes

→ Acrylic paint in several colors

→ Styrofoam block

→ Matte sealer (I used Mod Podge.)

**THESE BEADS ARE INSPIRED BY BRIGHTLY COLORED WOODEN LOBSTER BUOYS.**
Pair them up with blue and white beads or other nautical components for jewelry with a seaside theme.

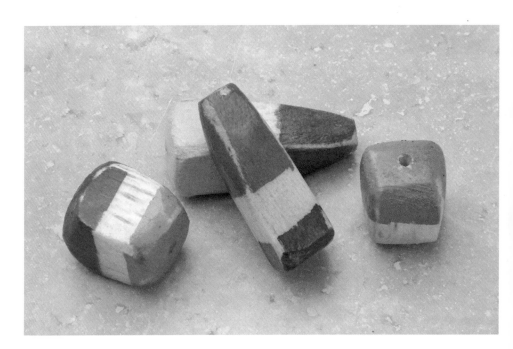

1. For long beads, use the ³/₈" (1 cm) -thick wood block. With the craft knife, cut off a 1" (2.5 cm) length of the balsa wood.

2. Hold one end of the 1" (2.5 cm) balsa wood and use the craft knife to cut the bottom of the bead in a tapered, slanted cut. Continue cutting each side of the bead, tapering it at the bottom. (Fig. 1)

3. For the square beads, cut the ½" (1.3 cm) wood block into ⁵/₈" (1.6 cm) lengths.

4. Sand each side of the beads with sandpaper. Beads can be shaped and edges rounded by sanding them. (Fig. 2)

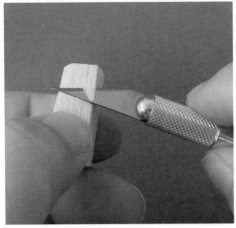
*Fig. 1*

*Fig. 2*

*Fig. 3*

*Fig. 4*

*Fig. 5*

5. Drill a hole vertically through the bead with the pin-vise drill. If the bead is longer than the drill, drill one side, and then drill the other side to meet in the middle. Use a piece of wire to poke through the bead to make sure you've drilled all the way through. (Fig. 3)

6. Wrap one end of the bead with washi tape to cover it. Place the bead on a toothpick and brush a thin layer of paint on the exposed end of the bead. Stick the toothpick into the Styrofoam block and allow the paint to dry. Remove the tape. (Fig. 4)

7. Repeat step 6 with a second color, wrapping tape over the painted end of the bead and covering a small strip of the unpainted bead. When the paint is dry, remove the tape. Allow it to dry completely.

8. Sand the edges of the beads to reveal the wood. (Fig. 5)

9. Place the bead on the end of a toothpick and apply an even coat of sealer. Poke the toothpick into the foam block to hold the bead while it dries completely. Repeat with a second coat.

# ACORN BEADS

## TOOLS AND MATERIALS

→ Acorn tops

→ Scrap wood block

→ Rotary tool with 2 mm drill bit

→ Paintbrushes

→ Polyurethane sealer
  (I used Minwax Polycrylic
  in Clear Satin.)

→ Polymer clay

→ 18-gauge wire bead mandrel,
  4" (10.2 cm) long

→ White embossing powder

→ Bead baking rack

→ Baking sheet

→ Alcohol ink (I used Adirondack
  Alcohol Ink by Ranger in the
  color Lettuce.)

→ Plastic lid

→ Microcrystalline wax
  (I used Renaissance wax.)

→ Soft cloth

**I LOVE FINDING ACORNS ON WOODLAND WALKS AND INCORPORATING ACORN THEMES INTO MY JEWELRY.** Unfortunately, the nut of the acorn can have worms so they are not ideal for jewelry projects. Save the tops and create your own polymer clay nuts to take the place of the real thing. The coloring of the polymer clay with the real acorn top can bring whimsical style to a jewelry creation. After you've rounded up your acorn tops, place them on a tray and let them dry for a few days indoors.

1. Place the acorn cap, open side down, on top of the block of wood. Hold the cap firmly with one hand and the drill with the other. If the acorn has a stem, drill slightly to the side of the stem. If the stem is missing, drill through the center of the cap. (Fig. 1)

2. Paint a coat of polyurethane sealer over the surface of the tops. Allow them to dry completely.

3. Roll a small piece of polymer clay into a ball about the same diameter as an acorn cap. Press the ball firmly into the cap. With your fingertips, shape the clay into a pyramid shape. (Fig. 2)

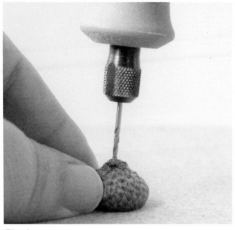
Fig. 1

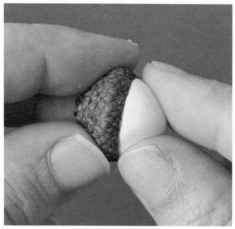
Fig. 2

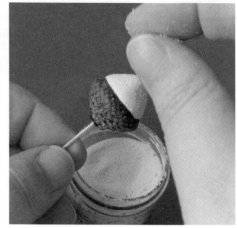
Fig. 3

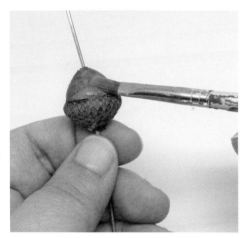
Fig. 4

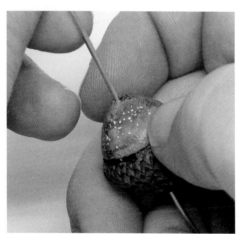
Fig. 5

4. Poke the wire bead mandrel through the hole in the acorn cap and all the way through the clay. Reshape the clay as needed to resemble an acorn. Leave the bead on the wire; 2 or 3 beads can be held on each wire.

5. Sprinkle a small amount of embossing powder sparingly over the surface of the clay. Wherever the powder falls, there will be a white dot on the bead after it's painted. (Fig. 3)

6. Put the bead on the wire on the bead rack. Place the rack on the baking sheet and bake according to the manufacturer's directions. Allow the beads to cool.

7. Put a few drops of alcohol ink on the plastic lid and paint the surface of the polymer acorn "nuts." Allow them to dry. (Fig. 4)

8. Use your fingernail to scrape off the embossing powder to reveal the white spots under the paint. (Fig. 5)

9. Rub a thin layer of Renaissance wax over the clay part of the bead and buff with a soft cloth.

# CAROL DEKLE-FOSS
## TERRA RUSTICA DESIGN

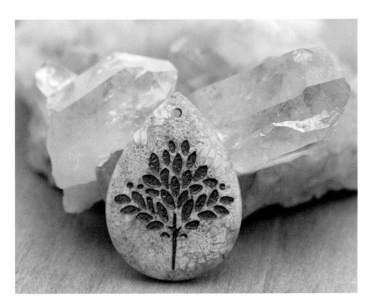

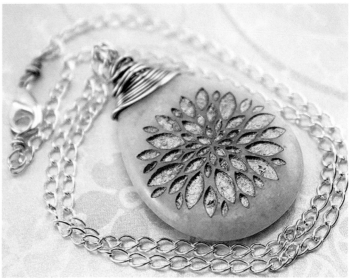

CAROL IS A MIXED-MEDIA BEAD ARTIST WHOSE WORK RANGES FROM UNIQUE STONE PENDANTS AND ETCHED METAL BEADS TO METALWORK JEWELRY AND CERAMIC BEADS. ALTHOUGH HER EARTHY PIECES ARE MADE WITH MANY MATERIALS, THEIR STYLE SPEAKS WITH ONE SINGULAR VOICE.

**Q:** I first discovered you when I was drawn to your sandblasted stone pendants. Can you explain how you create those and how you started on that journey?

**A:** What I do, basically, is place a stencil on a pendant and then sandblast with an abrasive material applied at high pressure. The sandblasting creates a low area in the design that I then paint with acrylic. My journey started with the single intent to sandblast custom designs onto river rocks. I liked the idea of taking something so simple in form from nature and turning it into a piece of art. I then was invited to a jewelry party where I saw a necklace with a stone pendant as the focal point. I thought, what if I could sandblast designs onto stone pendants and create jewelry? I did some more research and then started down an amazing path of creating wearable art.

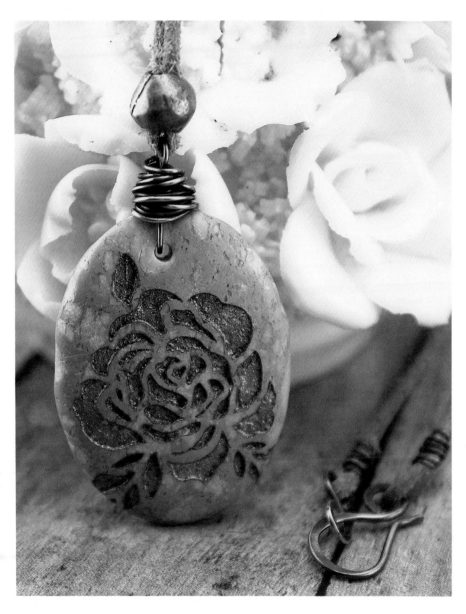

**Q:** You work in so many different mediums as a jewelry artist: metal, ceramic, and stone. What are your inspirations?

**A:** I am a visual person inspired by the wildness and beauty of the natural world and by different cultures. I work with diverse mediums as a way to discover what it is that interests and excites me. Right now, I am in love with ceramics and am finding new ways to use this medium as a way to further express my artistic voice.

**Q:** As a mixed-media designer, how do you choose which materials to use to create a jewelry design?

**A:** Really, I choose a medium by whatever I am most excited about at the time. I will then add mediums or different techniques as a way to enhance interest and create variety in the piece I'm creating.

**Q:** How do you keep your vision and unique style across mediums?

**A:** Developing a cohesive look in one's work takes many years to develop and hone. It's a process that takes patience, dedication, and hard work. My distinctive style has evolved over the past few years, but I have tried to retain my love of nature in my work. This journey as a jewelry designer has been a way for me to discover my true self. Along the way, I have been able to share my story, which to me has been the greatest gift.

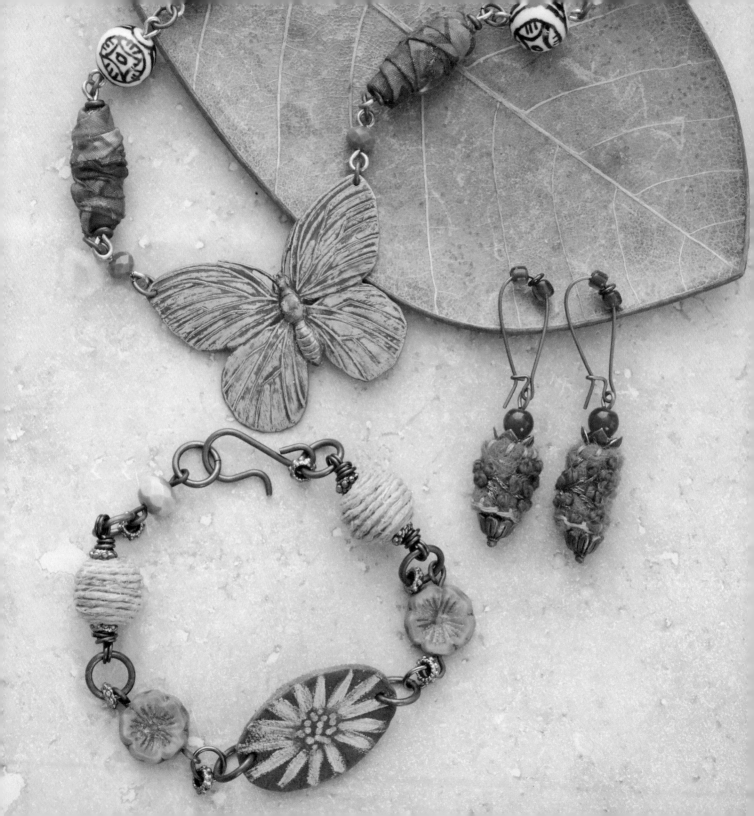

# FIBER AND TEXTILES

## FIBER BASICS

**Felting** is the process of interlocking wool fibers to create a solid. Wool fiber that's been carded and dyed is known as *roving*. Roving can be wet-felted with warm water, soap, and friction, or needle-felted with a barbed needle. When needle-felting, work slowly and steadily. Watch your fingers. Barbed felting needles are quite painful. When wet-felting, use very little water at the start of the felting process. Too much water will prevent the felt from forming a smooth surface.

Experiment with different types of **fabric, ribbon, twine, and rope** in any of the projects presented here. Each material will give you a different look. You can combine fabric with more durable material, and protect fabric surfaces with matte sealer.

**Scrap leather** for jewelry can be upcycled from old belts or bags. Craft stores sell small pieces of leather in different colors. Sealing painted leather can be done with clear shoe polish.

## TOOLS AND MATERIALS

→ Wool roving
(I recommend merino wool.)

→ Foam sponge

→ Felting needle

→ Hot water

→ Mild dish soap
(fragrance- and dye-free)

→ Towel

**TINY BITS OF FELT ARE FORMED INTO BEADS THAT WILL ADD TEXTURE AND COLOR TO YOUR JEWELRY DESIGNS.** These beads are first needle felted and then rolled with hot, soapy water to tighten the shape.

1. Pull off a piece of wool roving that is 2″ x ¼″ (5 cm x 6 mm long). Roll it in your fingers several times over to form a small ball. (Fig. 1)

2. Place the small ball on the foam sponge. Punch the tip of the felting needle into the center of the ball to tangle the fibers. Pull the needle out, turn the ball over, and repeat. Continue turning the ball and inserting the felting needle every quarter turn, always poking toward the center of the bead to create a small round shape. (Fig. 2)

*Fig. 1*

*Fig. 2*

*Fig. 3*

*Fig. 4*

3. Dip the bead into hot water. Put a drop of soap in the palm of your hand. Roll the wet bead between your palms, pressing tightly as you roll. Continue rolling until the bead is hard and smooth. Roll the bead back and forth to form it into an oval. (Fig. 3)

4. Press the bead with the towel to remove excess water. Allow the bead to dry overnight.

5. Poke the felting needle into the center of the bead, working the bead onto the thickest part of the needle. Turn the bead over and repeat, creating a hole all the way through. (Fig. 4)

# LAB 41

# STRUNG-OUT
## FELT BEADS

## TOOLS AND MATERIALS

→ 4 colors of 4-ply wool yarn

→ Scissors

→ Tray or dish

→ Hot water

→ Mild dish soap
(fragrance- and dye-free)

→ Vinegar

→ Towel

→ Darning needle

## TIP

You'll need yarn that is 100 percent wool. This project will not work with other fibers.

**WOOL YARN FELTS UP BEAUTIFULLY WITH THREE SIMPLE THINGS:** hot water, soap, and friction. Incorporating wool beads into your jewelry is a great way to add texture and color without adding weight. Create a bright mix of colors or a muted color scheme. If you are a knitter, this is great project to use up scraps of yarn.

1. Cut thirty-two 2" (5 cm) pieces of yarn. You can use one color or a combination of several colors.

2. Unravel each piece of yarn into single-ply strands. Place the strands on a tray, overlapping them in a circular pattern to create a large puff ball of wool strands. You'll have 128 pieces of yarn unraveled for each bead. (Fig. 1)

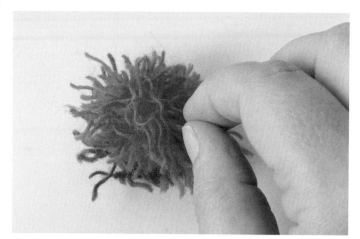

Fig. 1

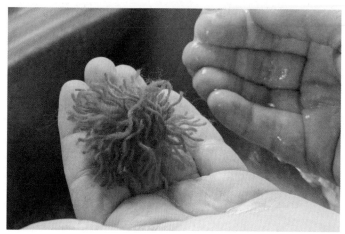

Fig. 2

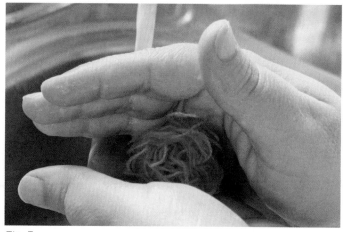

Fig. 3

3. Place the tray next to your sink and run the hot water. Wet your hands. Put a small drop of dish soap in your palm. Grab the ball of yarn for one bead and loosely roll it in your hands. Keep your hands together without putting too much pressure on the yarn. Continue rolling the ball until it's slightly damp. Tighten your hold on the ball a little more as you roll. (Fig. 2)

4. Add a few drops of water and continue rolling as the ball starts to shrink. Tighten your hands as you roll the ball again until it forms a solid mass. Continue rolling until the ball can't be squeezed any tighter. (Fig. 3)

5. Add a 1 tablespoon (15 ml) of vinegar to 1 cup (235 ml) of water and mix. Dip the bead in the mixture and rinse with warm water.

6. Squeeze the extra moisture from the ball with a towel. Roll to reshape if needed.

7. Allow the bead to dry. Poke a hole through the bead with a darning needle for use in jewelry.

# OAK LEAF PENDANT

## TOOLS AND MATERIALS

→ Cookie cutter

→ Dense foam block

→ Wool roving

→ Felting needle

→ Brown embroidery thread

→ Metallic embroidery thread

→ Embroidery needle

→ Beading thread

→ Beading needle

→ Size 10 beading needle

→ 15 to 20 size 11/0 metallic seed beads

## TIP

A beading needle is not the same as a sewing needle. It has a very fine head to allow it to pass through tiny beads. Beading thread is specially made for stringing beads and works much better than regular thread. You'll find specialty needles and thread in the beading section of craft stores.

**THIS PENDANT USES AN OAK-LEAF COOKIE CUTTER TO CREATE ITS INTERESTING SHAPE.** The needle-felted form is embellished with metallic embroidery thread and beads for a bit of bling.

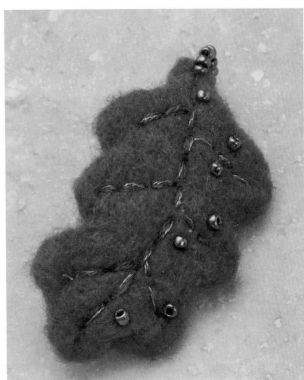

1. Place the cookie cutter on top of the foam block. Tear off several small pieces of roving. Place them, overlapping, inside the cookie cutter. Fill the cookie cutter to the top with roving. (Fig. 1)

2. Starting in the center, poke the felting needle up and down evenly over the surface of the roving. Flip the cookie cutter over and felt on the other side. Flip it again, back and forth, until you have a solid felted piece of wool. (Fig. 2)

3. Remove the cookie cutter. Carefully needle-felt the edges of the leaf.

4. Cut a 24 (61 cm) length of both the brown and the metallic embroidery flosses. Separate two of the strands of brown floss and set aside the rest for another project. Separate one strand of the metallic embroidery floss and line it up with the two strands of brown. Thread the three strands into an embroidery needle and knot the end.

5. Embroider the center of the leaf with the backstitch. Start at the base of the leaf on the underside. Thread the needle up through to the top, make a 1/4" (6 mm) stitch, and sew back down through. Skip a 1/4" (6 mm) length and sew back up through to the top. Backstitch by pushing the needle down through the hole at the end of the first stitch. Repeat the backstitch to the end of the leaf, ending with the needle on the underside. (Fig. 3)

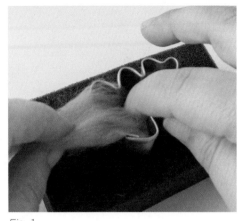
Fig. 1

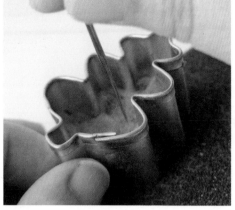
Fig. 2

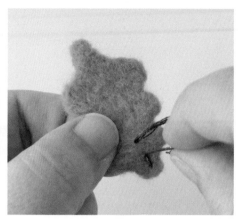
Fig. 3

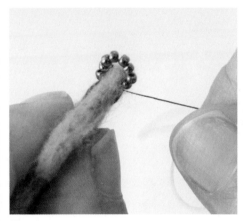
Fig. 4

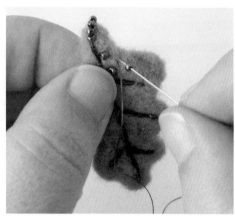
Fig. 5

6. Create the veins in the leaf. With the needle still on the underside, pull the needle through the felt, then up to the top surface. This will keep the visible stitches on the underside of the leaf at a minimum. Backstitch the first vein. Repeat this step to create two or three rows of veins on either side of the leaf.

7. Make a knot on the underside of the leaf. Pull the needle through the back layer of the felt ½" (1.3 cm) away from the knot. Pull the thread tightly, and cut it. The thread end will disappear into the felted leaf.

8. Create a loop. Cut a 24" (61 cm) length of beading thread. Thread it into a beading needle and tie a double knot at the end. Sew up through the felted form at the top of the leaf stem

where the embroidery ends, add 8 beads, and pull the needle to the back of the leaf. Sew through the leaf to the front where the beads start to form a loop. Pull the thread and needle through the beads again and sew again through the leaf. Repeat two more times to secure the loop. (Fig. 4)

9. Pull the needle up through the leaf to the side of the center vein, add a bead, and sew back down through the leaf next to the bead. To move to a new section, pull the thread through the leaf before bringing up the needle. Sew a random pattern of beads on the leaf as desired. When finished, tie a double knot. Pull the needle through the felt on the back of the leaf. Pull the thread tightly and cut. (Fig. 5)

## TOOLS AND MATERIALS

→ Wool felt sheet

→ Scissors

→ Metallic embroidery floss

→ Embroidery needle

→ Embroidery floss in 2 colors

**TIP**

Due to the natural, uneven texture of wool felt, you may want to trim 1" (2.5 cm) from the edges of a felt sheet before cutting out pieces for beads.

**THESE SMALL FELT BEADS ARE EMBELLISHED WITH SIMPLE EMBROIDERY FOR A FOLK-ART FEEL.** Change the colors of the felt and thread to create endless variations. I chose wool felt for these beads. Wool felt is thicker than acrylic (or craft) felt. If you use acrylic felt, you'll want to wrap a piece several times to create a thicker base bead.

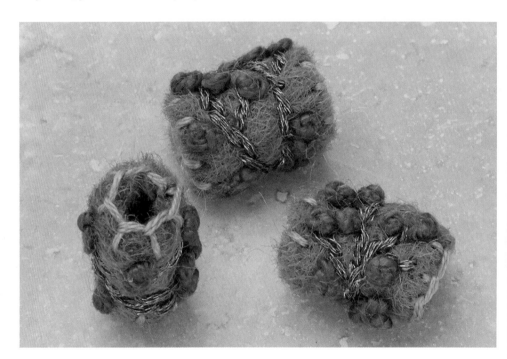

1. Cut a ½" x ¾" (1.3 x 2 cm) piece of felt.

2. Cut a 24" (61 cm) length of metallic floss. Thread the needle. Tie a knot at the end.

3. Stem-stitch a branch. Start at the middle left on the underside of the small rectangle of felt. Pull the needle up through the felt and make a small stitch. Pull the needle up through again, next to the center of the first stitch. Make another stitch the same length. Repeat the stem stitch to create a branch design. On the underside of the felt, tie a knot and trim the thread. (Fig. 1)

4. To make French knot flowers, cut a 24" (61 cm) length of embroidery floss. Thread the needle and tie a knot at the end. Pull the needle up through the felt where you'd like

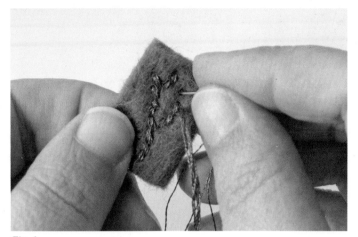

Fig. 1

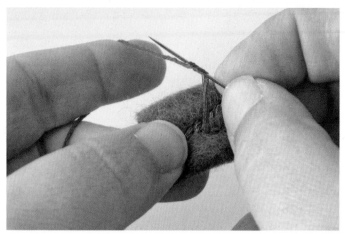

Fig. 2

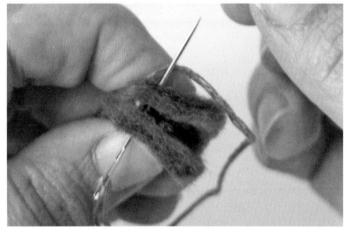

Fig. 3

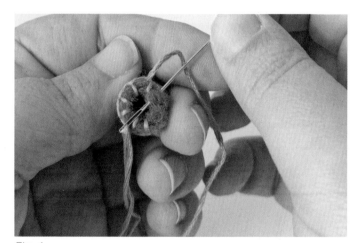

Fig. 4

the first flower to be. Pull the thread tight. At the base of the thread, where it emerges from the felt, wrap the needle around the thread twice and push the needle back down through the felt again. Hold the thread tightly until all the thread is pulled through and a small knot has formed. (Fig. 2)

5. Create French knot flowers along the tree branch stitches. When you get to the end, tie a knot on the underside of the felt and cut the thread.

6. Blanket-stitch the seams of the bead. Cut a 24″ (61 cm) length of embroidery floss in the second color. Thread the

needle and tie a knot. Bend the felt piece into a tube. Hold it in this shape while you stitch. (Fig. 3) Start the thread on the inside of the bead, at the top of the seam. Pull the needle through the felt. Stitch the two pieces together, pulling the top thread over the needle before you pull it all way through the felt. Repeat along the seam, securing the bead.

7. Blanket-stitch the edge of the tube. Pull the needle through the bead and blanket-stitch the other end of the tube. Tie a knot inside the bead and trim the thread. (Fig. 4)

## TOOLS AND MATERIALS

→ Wool felt

→ Scissors

→ Variegated embroidery floss

→ Embroidery needle

→ Pearl cotton thread

→ Metallic embroidery floss

→ Beading thread

→ Beading needle
   (see Tip on page 112)

→ 15 to 20 size 11/0 glass
   seed beads

**THERE ARE MANY DESIGN OPTIONS FOR THIS FIBER-INFUSED FLOWER BEAD.** Two layers of felt give it a strong base for embellishing with embroidery floss and glass seed beads. Use wire, a headpin, or beading wire to thread through the two pieces of felt for use in your jewelry designs.

1. Cut two 1" (2.5 cm) round pieces of felt.

2. Cut a 36" (91.4 cm) length of embroidery floss. Thread an embroidery needle with a strand of the floss and knot the end. Pull the needle and thread through the first piece of felt, just off center. Place the second piece of felt underneath the first, sandwiching the knot in between. (Fig. 1)

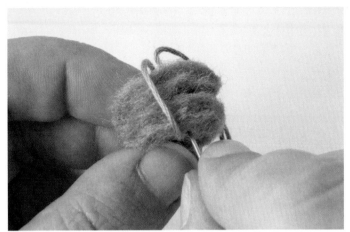

*Fig. 1*

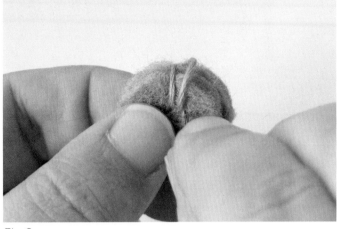

*Fig. 2*

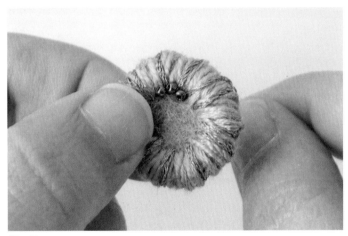

*Fig. 3*

3. Wrap the thread over the edge of the felt, around to the back of the bead, and then up through the center. Pull the threads firmly but not too tight. Repeat, working your way around the circle, so that the stitches appear like the spokes of a wheel. Leave a 1/4" (6 mm) circle at the center for the seed beads. Tie off the thread on the back of the bead, pull the thread through the bottom of the bead again, and pull the thread tightly before cutting. (Fig. 2)

4. Repeat steps 2 and 3 with the pearl cotton thread.

5. Repeat steps 2 and 3 again with the metallic embroidery floss.

6. Cut a 36" (91.4 cm) length of beading thread and thread it into a beading needle. Pull the needle up through the felt circle at the center, add a seed bead, and pull the needle through the felt. Continue sewing seed beads around the center of the bead. Finish by tying the thread at the bottom of the felt and pull it sideways through the two layers of felt. Pull the thread tightly before cutting the thread; the thread will be hidden between the two layers. (Fig. 3)

# ROLLED FABRIC
## BEADS

## TOOLS AND MATERIALS

→ ⅛ yard (11.4 cm) of batik fabric

→ Scissors

→ Hollow plastic coffee stirrers

→ Quick-dry tacky glue

→ 18-gauge wire

→ Paintbrush

→ Matte sealer (I used Mod Podge.)

→ Bead rack

## TIP

The sealer will stiffen the fabric. For softer fabric beads, glue more often while rolling the layers around the bead to secure the fabric. Omit the step on sealing the beads.

**ROLLED FABRIC CREATES COLORFUL AND TEXTURE-RICH BEADS.** The strength of these beads comes from a piece of a plastic coffee stirrer hidden at the core. A coffee stirrer has the perfect size hole. I used batik fabric for these beads because the color is strong on both sides of the fabric. You can experiment with other types of fabric, too. Try dupioni silk for great results.

1. Open the piece of fabric on your work surface. Find the finished (selvedge) edge of the fabric. With the scissors, make a cut parallel to and 1″ (2.5 cm) in from the selvedge. Hold both sides of the cut and tear the fabric all the way along its length. You'll have a long ribbon of torn fabric that will make 4 or 5 beads. (Fig. 1)

2. Cut the coffee stirrers into 1 ⅛″ (3 cm) lengths.

Fig. 1

Fig. 2

Fig. 3

Fig. 4

3. Stretch out the ribbon of fabric. Squeeze a line of glue across the short end of the ribbon. Center a piece of coffee stirrer on the glued end. Beginning at one end of the stirrer and, working toward the other, wrap the fabric tightly. (Fig. 2)

4. Twist the fabric where it meets the stirrer and continue wrapping a layer around the entire stirrer, twisting the fabric several times as you wrap. This is the first layer. (Fig. 3)

5. When you get to the end of the stirrer, create a second layer, twisting the fabric again and wrapping it back toward the center of the bead. Wrap around the center twice to create a bead that is thicker in the middle. Continue wrapping and twisting the fabric to the other side of the stirrer. When you get to the end, cut the ribbon and glue the end down firmly.

6. Place the bead on the wire and brush on a layer of sealer. Let the beads dry on the bead rack. (Fig. 4)

## TOOLS AND MATERIALS

→ 2 mm hemp cord

→ Measuring tape

→ Scissors

→ Fast-drying tacky glue

→ Unpainted wooden beads

→ Toothpicks

→ Paintbrush

→ Matte sealer
  (I used Mod Podge.)

→ Styrofoam block

**THIS NAUTICAL-INSPIRED BEAD IS SO EASY TO WHIP UP YOU'LL HAVE A PILE OF ROPE BEADS IN NO TIME.** Use different sizes of wood beads for variation.

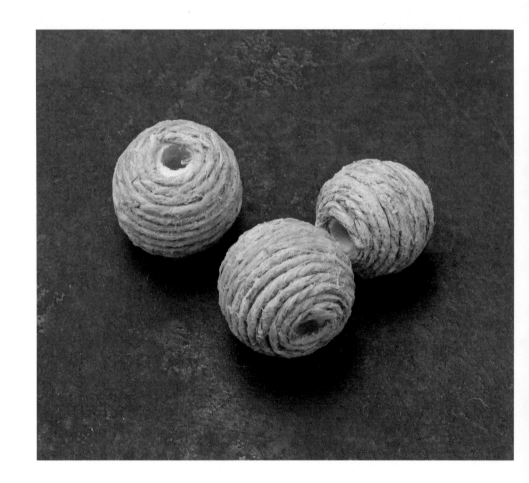

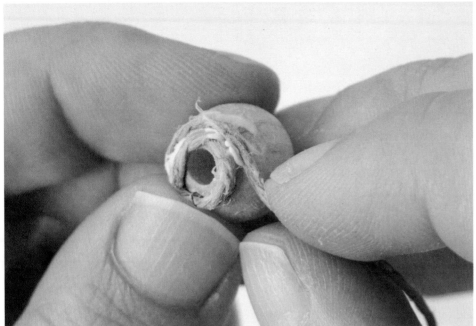

*Fig. 1*

1. Cut a 12" (30.5 cm) piece of cord.

2. Spread a few drops of glue around the hole at the top of a wooden bead. Wind the cord tightly around the hole, pressing it into the glue. (Fig. 1)

3. Apply another line of glue around the center of the bead. Continue winding the cord tightly around the bead. Repeat until the bead is completely covered. Trim the cord. Allow the glue to dry. (Fig. 2)

4. Place the bead on a toothpick and brush on a layer of matte sealer. Allow it to dry completely.

*Fig. 2*

# BLOSSOM BRACELET
## CUFF

## TOOLS AND MATERIALS

→ Permanent marker

→ 2" x 2" (5 x 5 cm) piece of ⅛"
   (3 mm) -thick leather

→ Sharp scissors

→ Small-hole punch
   (¹⁄₁₆" [2 mm])

→ Fine-grit sanding block

→ Paintbrush

→ Acrylic paint (I used copper
   and light purple.)

→ Sheet of thick cardboard

→ Leather spoon and shaping
   tool

→ Oil-based paint pen in gold
   (I used a Sharpie.)

→ Clear shoe polish

→ Soft cloth

**USING A LEATHER SPOON AND SHAPING TOOL ALLOWS YOU TO IMPRESS A DESIGN ONTO THE LEATHER.** The shaping tool is double-ended. The sharper end looks like a dull knife and is used to create lines. The spoon side of the tool creates wider impressions in the leather. Let some of the leather show through the paint on this cuff to play up its natural look. Pair the cuff with Czech glass and antiqued brass for an effortless design.

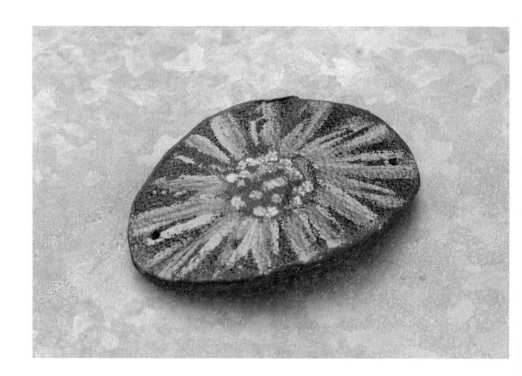

1. Draw a 2" x 1¼" (5 x 3.2 cm) oval with the marker on the leather. Cut out the shape with scissors. On the back side of the oval, use the marker to indicate where you want to make the holes. Punch a hole at both ends of the oval. (Fig. 1)

2. Use the sanding block to sand the edges of the oval, sanding from the front surface to the back. (Fig. 2)

3. Paint the back and the sides of the oval with the copper paint. Allow it to dry.

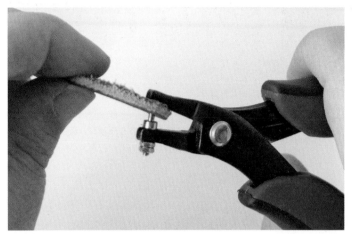
Fig. 1

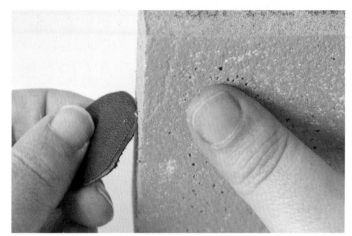
Fig. 2

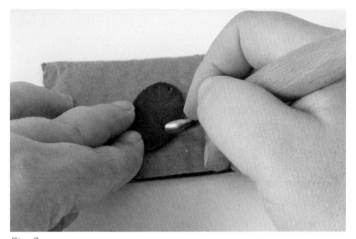
Fig. 3

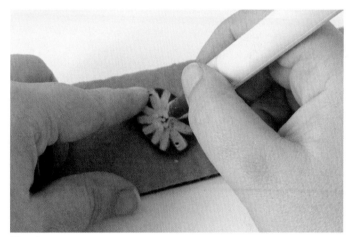
Fig. 4

4. Place the leather piece on the sheet of cardboard. Hold it firmly in place. Use the spoon (curved) side of the leather shaping tool to create petal shapes in the leather. Starting at the center, press the tool deeply into the leather in radiating spokes. (Fig. 3)

5. With a dry brush, paint the impressed outlines of the petals in purple acrylic. Allow the paint to dry.

6. With the gold pen, dab dots in the middle of the flower. Draw one slim line in gold on each flower petal. (Fig. 4)

7. When the ink has dried completely, use your fingers to shape the leather into a slight curve. Use the sanding block to lightly sand the surface of the paint to distress it slightly.

8. Coat the piece with a layer of clear shoe polish to protect the paint.

# LEATHER GINGKO
## LEAF PENDANT

## TOOLS AND MATERIALS

→ ⅛" (3 mm) -thick leather scraps

→ Marker

→ Sharp scissors

→ Small hole punch (¹⁄₁₆" [2 mm])

→ Fine-grit sanding block

→ Thick cardboard

→ Leather spoon and shaping tool (See Lab 47: Blossom Bracelet Cuff.)

→ Paintbrush

→ Acrylic paint (in dark green, two light shades of green, and brown)

→ Water

→ Paper toweling

→ Clear shoe polish

→ Soft cloth

**THIS EARTHY LEATHER PENDANT USES A SCRAP OF LEATHER.** Vegan leather is also available for those who prefer it.

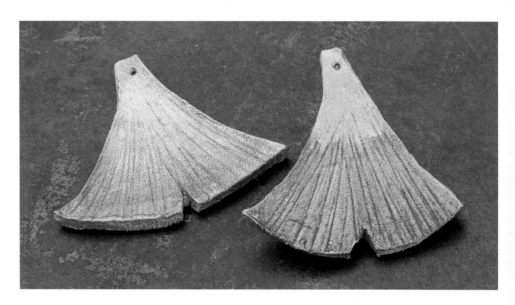

1. Draw the shape of a ginkgo leaf on the leather and cut out the shape with scissors. (Fig. 1)

2. Use the hole punch to punch a hole at the top of the leaf. Draw the lines for the veins of the leaf.

3. Sand the cut edges of the leather with the sanding block, working from front to back.

4. Place the leather leaf on the cardboard and hold it firmly in place. Using the sharper end of the shaping tool and pressing firmly, trace the veins of the leaves. (Fig. 2)

5. Use the spoon end of the shaping tool to impress the leather on each side of the vein. Line up the end of the spoon along the vein starting at the top of the leaf. Press firmly with the tool and drag it along the vein, making an impression next to the vein. Repeat along the entire leaf. (Fig. 3)

6. Using a dry brush, paint dark green along the wider part of the leaf. Follow up with the two lighter colors as you work with the narrow part of the leaf. Use short, choppy

Fig. 1

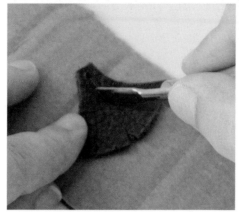

Fig. 2

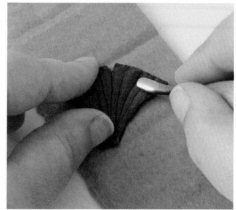

Fig. 3

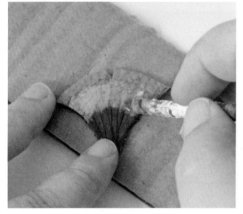

Fig. 4

brushstrokes that follow the veins on the pattern. Allow the paint to dry. Paint the back and sides of the leaf with the same gradation of colors. (Fig. 4)

7. Brush a light layer of brown paint over the entire front of the leaf. Wipe off the excess paint with a paper towel. Allow the paint to dry completely.

8. Coat the leaf with clear shoe polish to protect the paint.

## DESIGNER SPOTLIGHT:
## ◆ REBEKAH PAYNE ◆

**REBEKAH PAYNE** of Tree Wings Studio works in several mediums, making beads from materials including polymer clay and leather. Her leather wing pendants feature designs that she draws with a wood-burning tool and hand-paints with acrylics. Through explorations in bead making, Rebekah has discovered a visual language that she translates from polymer clay to leather through color and mark making. Explore repetitive mark making in leather to create your own designs with geometric and tribal patterns.

# KNOTTED LEATHER
## BEADS

## TOOLS AND MATERIALS

→ 18" (45.7 cm) of leather cord

→ 12 mm wooden bead

→ Fabric glue

→ Scissors

**THIS BEAD USES A COMMON KNOTTING TECHNIQUE CALLED THE MONKEY FIST.** It looks complicated, but it's actually an easy layering of leather cord. Each time you wrap the leather, line up each cord so that they lie flat next to each other.

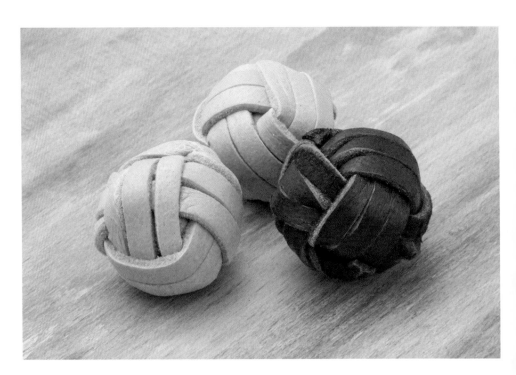

1. Wrap the leather around your index finger four times, so that the wraps lie next to each other. Gently pull the leather off your finger. (Fig. 1)

2. Wrap the end of the cord around the center of the first four rounds of cord. Repeat this two more times, allowing the wraps to lie next to the other. (Fig. 2)

3. Gently pull one side of the leather wraps open and slip in the wooden bead. Position the bead so that the hole lines up with the end of the leather (it will be easier to find when the bead is finished). (Fig. 3)

Fig. 1

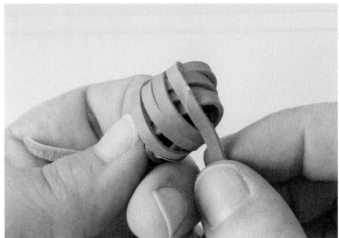

Fig. 2

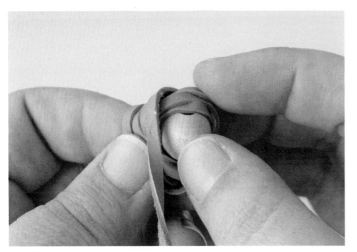

Fig. 3

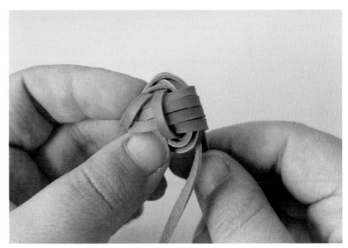

Fig. 4

4. Wrap the cord to the front of the bead and insert the end of the cord under the top layers of leather and around the wooden bead. Insert the cord back up through the bottom cords. Continue wrapping the cord three times around the wooden bead. (Fig. 4)

5. Starting at the end of the cord, tighten each part of the leather cording. Work back and forth around the bead, as you would to tighten up a shoelace. You may have to tighten the leather twice before the bead is done. There should be no play in the leather.

6. Lift the ends of the leather. Add a dab of glue and trim the leather closely to the bead. Press the ends until the glue has set.

Remember, the bead's hole will be near the start of the leather cord.

A TRADITIONALLY TRAINED ARTIST, GAIL CROSMAN MOORE HAS TURNED TO A VARIETY OF BEAD-MAKING MEDIUMS TO EXPRESS HER CREATIVE VISIONS. SHE WORKS IN GLASS, PAPER, AND FELT TO CREATE BEADS INSPIRED BY NATURE. GAIL IS A RENOWNED INSTRUCTOR AND TEACHES HER BEAD-MAKING TECHNIQUES AROUND THE GLOBE.

**Q:** Your work is immersed in color and texture. How have your art studies influenced your bead making?

**A:** That is a difficult question to answer. For me, the color, texture, and surface of a piece—along with form, of course—are what scream to be let out. It's the juxtaposition of these things that make me want to include new materials and dance with hot, cold, shiny, matte, soft, and hard. My art studies are what have given me the skills to be fluid with many materials.

**Q:** Pods and florals are recurring elements in your work. Do you sketch from nature or let your memory be your guide in recreating these forms?

**A:** I've never been much for preliminary drawing, I'd much rather dig into the materials and create a 3-D form. I rarely try to depict anything that already exists unless it is a casting from nature. I use my memory to hopefully distill the important parts of pods and growth forms in my work.

**Q:** What are some ways you renew your creative spirit and search out new ideas?

**A:** I tried to catch the sunrise, and possibly a sunset, too, every day while in Provincetown [Massachusetts] this summer. This is witness to a new day, ripe with potential. My iPhone has served me well in composing ideas for some abstract painting. An intentional beauty-fueled daily field trip is a perfect goal for centering my visual scanner.

**Q:** How has working in a series or exploring the same themes helped you grow as an artist?

**A:** Like many artists, I have a short attention span. A series offers parameters and an anchor that connect piece to piece. This helps me hone my skills, distill my vision, and add richness and facets to an idea. The idea doesn't need to be explored in just one frame, bead, or object. Each piece can stand alone while adding richness to the whole.

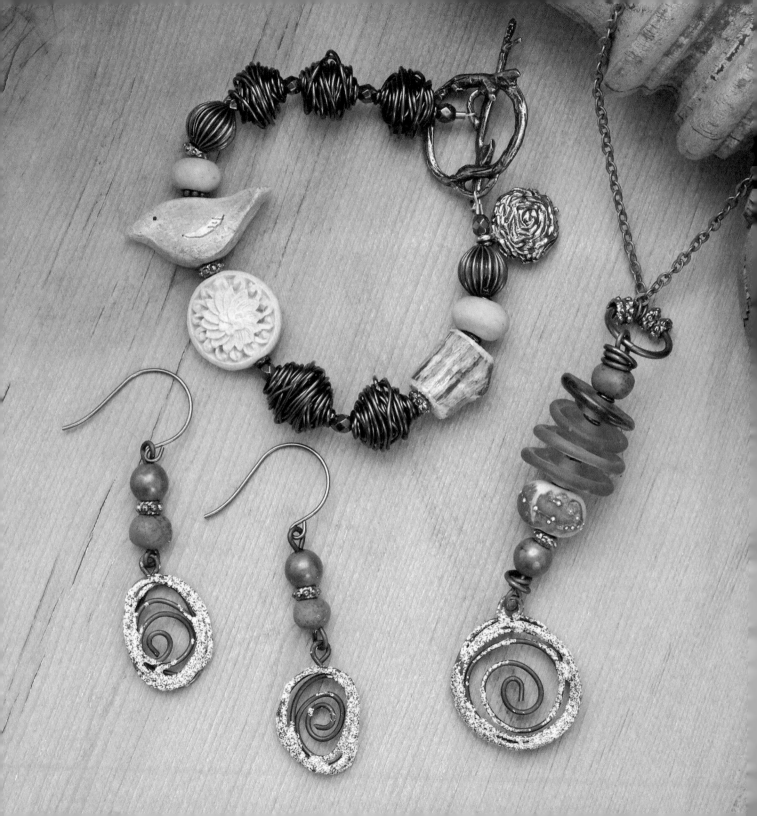

# UNIT 06

# WIRE

## WIRE BASICS

Creating beads and pendants from wire can bring a modern edge to your jewelry. Use the color of the wire as a design element when planning your creations.

**Coated copper** wire is the easiest to work with. It's soft and malleable. Different brands will give you different results. I recommend Parawire: the coating doesn't flake off when bent and hammered. Because coated copper wire is so soft, it needs to be hammered to harden it when using it to create shapes.

**Steel** wire is stronger than other wires and retains its shape without hammering. To cut it, use memory wire cutters (found in the jewelry section of craft stores) or an old pair of heavy-duty wire cutters. Steel wire also needs to be sealed to prevent it from rusting.

The larger the gauge number, the thinner the wire will be. In these projects, 19- or 20-gauge wires are used to create beads and frames; 26 gauge is used to embellish and wrap frames.

# FAUX ENAMEL

## TOOLS AND MATERIALS

→ Dark annealed steel wire

→ Measuring tape

→ Wire cutters

→ Steel wool

→ Paper toweling

→ Microcrystaline wax
  (I used Renaissance wax.)

→ Round-nose pliers

→ Chain-nose pliers

→ Translucent liquid polymer clay

→ Paintbrush

→ Embossing powder

→ Toaster oven with tray

→ Baby oil

**COLORFUL EMBOSSING POWDERS PROVIDE A POP OF COLOR ON DARK STEEL-WIRE FRAMES.** The trick to getting the embossing powder to stick on the wire is using liquid translucent polymer clay: the clay forms a bond for the embossing powder. You'll find dark annealed steel wire at a good hardware store. The wire needs to be treated before use to prevent it from rusting, so don't skip the first step!

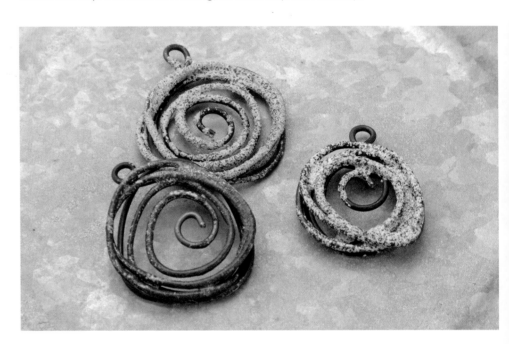

1. Cut a 12" (30.5 cm) piece of wire with the wire cutters. Rub the surface of the wire with the steel wool. Wipe it clean with a paper towel. Use your fingers to apply a thin layer of microcrystalline wax over the surface of the wire.

2. Hold one end of the wire with the round-nose pliers. Turn your wrist toward yourself to twist the wire into a spiral. (Fig. 1) Hold the spiral flat between the ends of the chain-nose pliers and continue to turn the wire to create a larger spiral.

3. Hold the wire with your hands and make a second row of spiraled wire around the outer edge; continue wrapping wire around the outer edge, inserting the wire into the outside of the spiral to build up the edge without making the pendant wider. (Fig. 2)

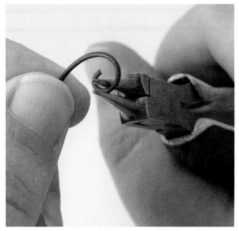

Fig. 1

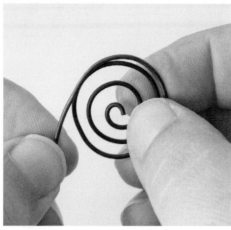

Fig. 2

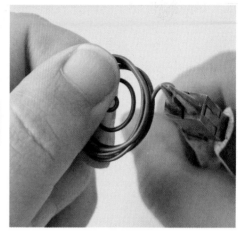

Fig. 3

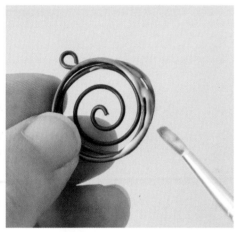

Fig. 4

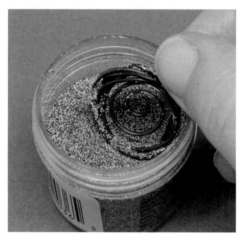

Fig. 5

4. When your spiral is the desired size, trim the wire with the wire cutters, leaving a ¼" (6 mm) tail. Use the round-nose pliers to grab the end of the wire and create a simple loop. Tuck the loop between layers of the wire. (Fig. 3)

5. Apply a thin coat of the liquid polymer clay to the outer edge of the spiral with a paintbrush. (Fig. 4)

6. Dip the painted edge of the spiral into the embossing powder. (If any embossing powder clings to the rest of the spiral, wipe it off with your finger.) (Fig. 5)

7. Preheat the toaster oven to 265°F (130°C) for 10 minutes. Place the spiral on the baking sheet in the oven for 15 minutes. Allow it cool completely before handling.

8. Clean your brush with baby oil and a paper towel.

# WIRE NEST BEADS

## TOOLS AND MATERIALS

→ 40" (101.6 cm) length of 20-gauge copper-colored wire (I used Parawire.)

→ Toothpick

→ Wire cutters

→ Chain-nose pliers

**USE COPPER-COLORED WIRE TO CREATE WRAPPED NESTS AS A PERCH FOR BIRD BEADS OR ON OWN THEIR OWN IN WOODLAND-INSPIRED DESIGNS.** Any wire can be used for this project but the copper-colored wire is soft and malleable. It comes in a variety of metallic colors to mimic brass, silver, gunmetal, and copper.

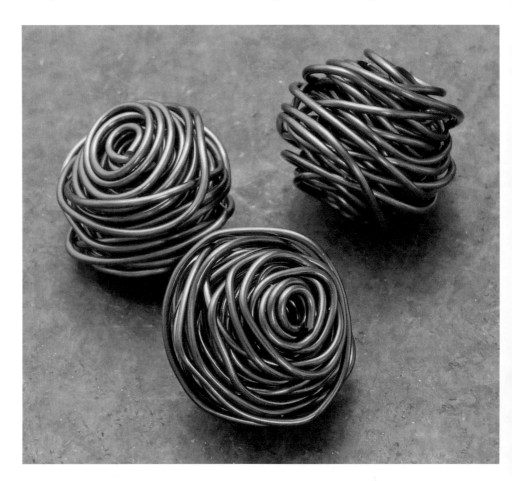

1. Beginning 3" (7.5 cm) from one end of the wire, wrap the wire around the toothpick several times. Don't wrap the wire too tightly. Continue wrapping until you have a ³/₄" (2 cm) base wrap around the toothpick. The remaining 37" (94 cm) of wire will be on the other end of the bead. (Fig. 1)

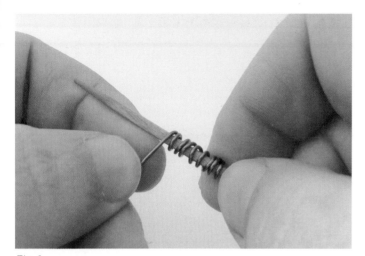

Fig. 1

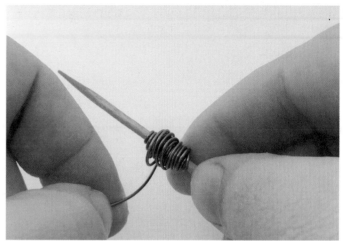

Fig. 2

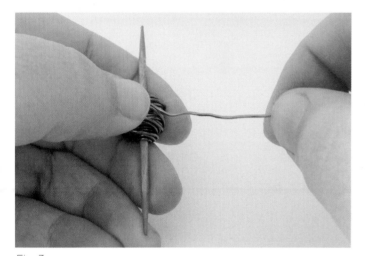

Fig. 3

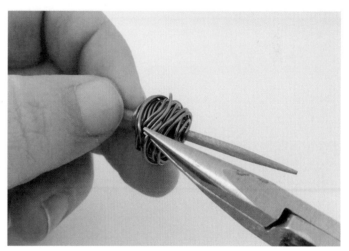

Fig. 4

2. Trim the remaining end of the 3" (7.6 cm) wire, if there is any left after wrapping it around the toothpick in step 1. Tuck the end into the wrapped wire, pressing it lightly with the chain-nose pliers.

3. Wrap the long piece of 37" (94 cm) wire around the nest base several times. Layer the wire loosely around the base, wrapping from the top to bottom of the bead. (Fig. 2)

4. When you have 12" (30.5 cm) of wire left, texture it by twisting it loosely. (Fig. 3)

5. Grab the wire 3" (7.6 cm) from the nest with the pliers and twist it several times. Grab the wire 3" (7.6 cm) from the last point and twist again. Repeat, twisting gently, until you reach the end of the wire.

6. Wrap the wire up and down the bead, overlapping previous rounds as you go to create the nest texture. Tuck the end of the wire into the nest and trim it. Pull the bead off the toothpick. (Fig. 4)

## TOOLS AND MATERIALS

→ Wire cutter

→ Ruler

→ 20-gauge antique brass–colored wire

→ Chain-nose pliers

→ 26-gauge antique brass–colored wire

→ Round and steel bench block

→ Ball-peen hammer

→ 150 to 200 size 11/0 seed beads

**WIRE FRAMES HOLD A RANDOM PATTERN OF TINY GLASS SEED BEADS TO CREATE PLAYFUL, EYE-CATCHING PENDANTS.** Experiment with different sizes and finishes of beads for a variety of looks with this design. You can create frames of different sizes to form pendants that fit your jewelry needs. The frames will need to be hammered to strengthen them. You can find economy bench blocks and ball-peen hammers wherever jewelry supplies are sold.

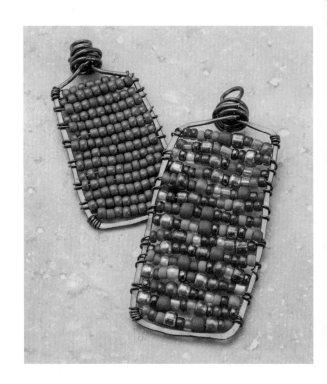

1. Cut a 12″ (30.5 cm) piece of 20-gauge wire with wire cutters. Find the center of the wire and bend it at a 90-degree angle using the chain-nose pliers. Measure 1″ (2.5 cm) from the center and bend the wire 90 degrees upward again to form the bottom of the rectangle. Measure 2″ (5 cm) up from the bottom of the rectangle on each end, bending both sides of the wire toward each other at 90-degree angles to form the top of the rectangle. (Fig. 1)

2. At the center top of the rectangle, use the round-nose pliers to grab the end of one of the wires. Form a loop. Hold the loop with the chain-nose pliers and wrap the loose end under the loop two or three times to hold it in place. Trim the wire. (Fig. 2)

3. Continue holding the loop. Wrap the second wire under the loop and over the other wraps. Do this two or three times, wrapping the wire up and down to cover. Wrap the wire to the back of the frame and trim it. Use the chain-nose pliers to press the end of the wire into the wrap so it doesn't catch on anything. (Fig. 3)

Fig. 1

Fig. 2

Fig. 3

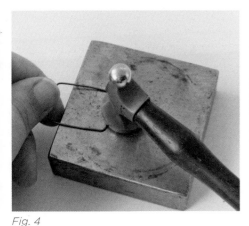

Fig. 4

Fig. 5

4. Place the wire frame on the bench block. Position it so the loop and wrapped section hang off the edge of the block. Hammer evenly over the surface of the frame. Turn the frame over and repeat hammering on the other side. Place the tip of the loop, not the wrapped section, on the block and hammer it gently. (Fig. 4)

5. Cut a 36" (91.4 cm) piece of 26-gauge wire. String 24" (61 cm) of seed beads on the wire.

6. Starting at the bottom of the frame, wrap the one end of the 26-gauge wire tightly around one side of the frame three or four times. Let the seed beads slide across the wire to the width of the frame. Pull the wire tightly across to the second side of the frame. Wrap it around the second side of the frame, wrapping over the wire and back under it twice. (Fig. 5)

7. Slide another set of beads across the wire. Pull the wire tightly, back to the first side of the frame, and wrap it over and under the wire twice. The beaded wire will always come from under the wire frame on one side and be wrapped over the wire frame on the other side.

8. Continue adding bead rows to the frame until you reach the top. Wrap the wire tightly around the frame three or four times. Trim the wire on the back of the frame. Press the end of the wire tightly to the frame with the chain-nose pliers.

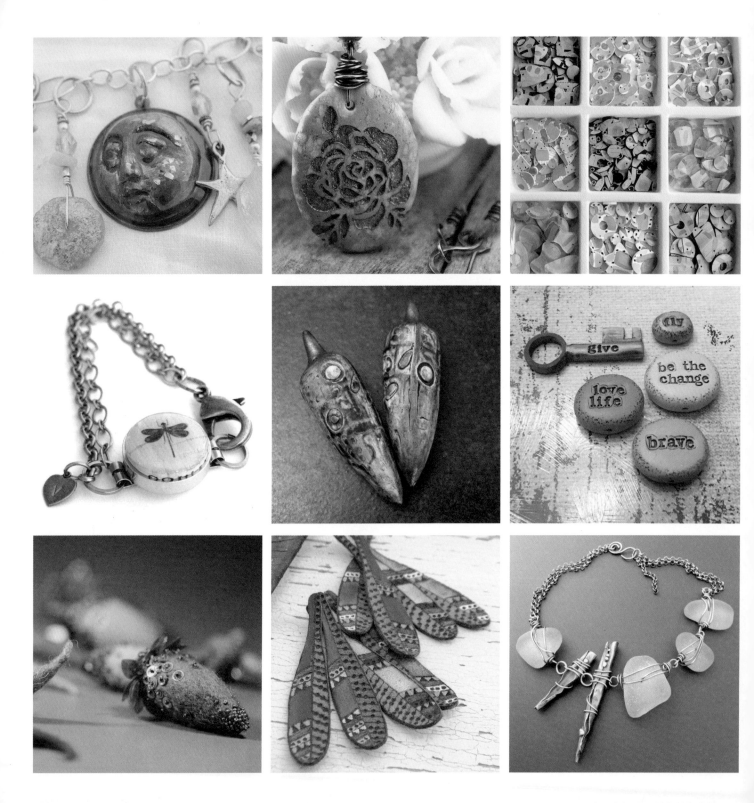

# DIRECTORY OF ARTISTS

**Jen Cushman**
www.jencushman.com

**Carol Dekle-Foss**
www.terrarusticadesign.com

**Yvonne Irvin-Faus**
www.myelementsbyyvonne.com

**Cat Ivins**
www.olivebites.com

**Claire Maunsell**
www.stillpointworks.blogspot.com

**Heather Millican**
www.etsy.com/shop/swoondimples

**Gail Crosman Moore**
www.gailcrosmanmoore.com

**Rebekah Payne**
www.treewingsstudio.com

**Staci Louise Smith**
www.stacilouiseoriginals.com

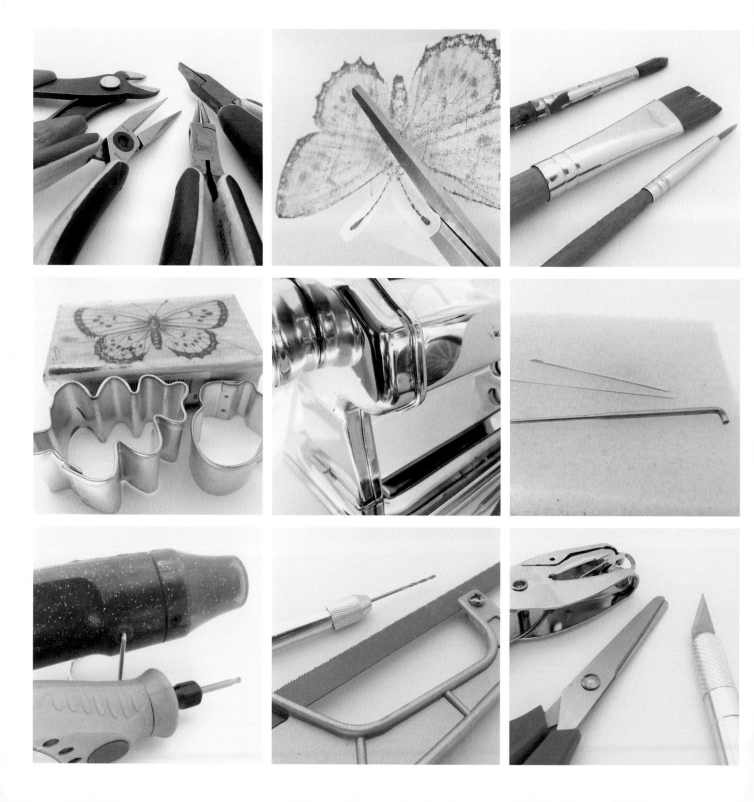

# RESOURCES

All of the materials in this book can be sourced at craft shops. Most of the tools are available from hardware stores. For specialty items as well as general supplies, try the online sources listed below.

**TOOLS**
www.acehardware.com

**FREE PRINTABLE GRAPHICS**
www.thegraphicsfairy.com

**GENERAL CRAFT AND BEAD SUPPLIES**
www.hobbylobby.com
www.michaels.com

**SPECIALTY SUPPLIES**
**Polymer clay and tools, and shrink plastic**
www.munrocrafts

**Alcohol inks, patina paints, beads, findings, Renaissance wax, Ice resin**
www.limabeads.com

**Alcohol inks, bead supplies, resin, and jewelry tools**
www.fusionbeads.com

**Resin, embossing powders, and bezels**
www.iceresin.com

**Steel wire and tools**
www.etsy.com/shop/brendaschweder

**Daily craft overstock deals** (rubber stamps, ink pads, alcohol inks, patinas, embroidery floss, and felting supplies)
www.blitsy.com

**Felting, resin, and beading supplies**
www.ornamentea.com

**Felting supplies and wool roving**
www.outbackfibers.com

# INDEX

# ABOUT THE AUTHOR

Heather Powers discovered beads almost twenty years ago and began creating wearable works of art while studying painting at art school. Just like the painters and poets that inspire her, Heather looks to nature as her muse as she translates those art school lessons into beads that reflect the beauty of nature. Her greatest joy is teaching and inspiring others on their creative journey.

Heather is a frequent contributor to bead magazines. Her popular blog *Art Bead Scene* (artbeadscene.blogspot.com) brings her love of handmade beads and art inspiration to jewelry designers around the world. Heather organizes an annual Bead Cruise and teaches at workshops and retreats around the country. She is the author of *Jewelry Designs from Nature* and *Beautiful Elements*.

You can learn more about her work at **www.humblebeads.com**.